The
Handbook of
Child
Photography

To my wife Michelle and sons
Nicholas and Matthew for their
support during the last ten years of
photography and their tolerance and
advice during the writing of this
book.

To my own mother and father for
their tolerance and advice during my
childhood.

The
Handbook of
Child
Photography

John Garrett

Pan Books Ltd London and Sydney

First published in Great Britain 1986 by
Pan Books Ltd,
Cavaye Place, London SW10 9PG
9 8 7 6 5 4 3 2 1
Text and photographs © John Garrett
1986
ISBN 0 330 29530 6
Photoset by Parker Typesetting Service,
Leicester
Printed in Italy by New Interlitho, Milan

Contents

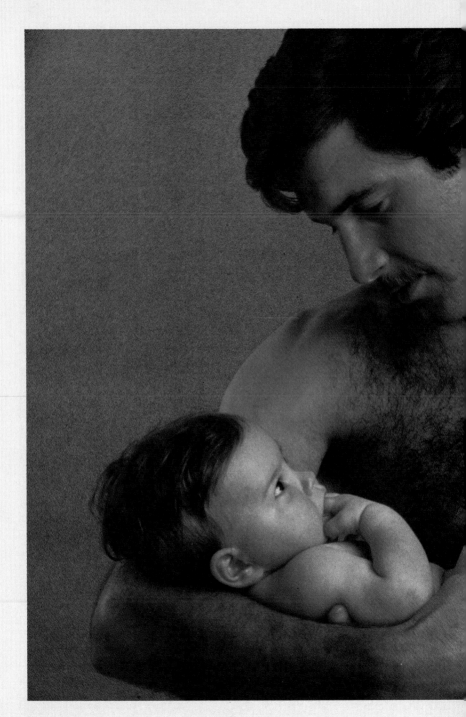

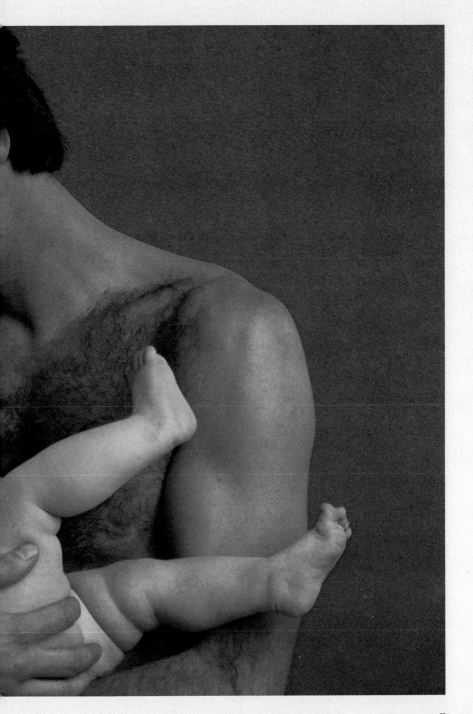

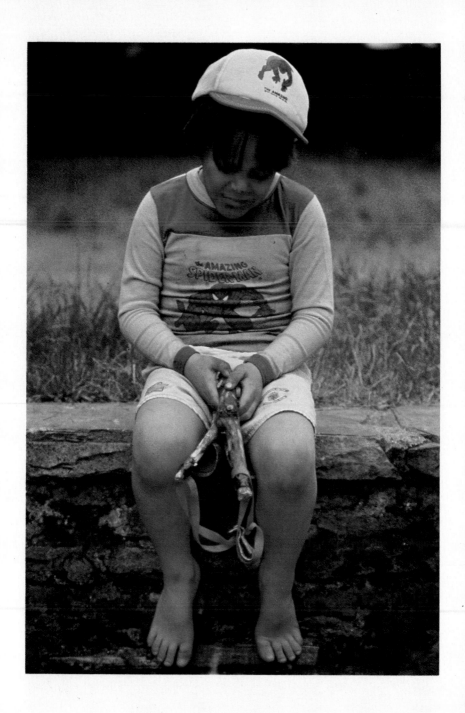

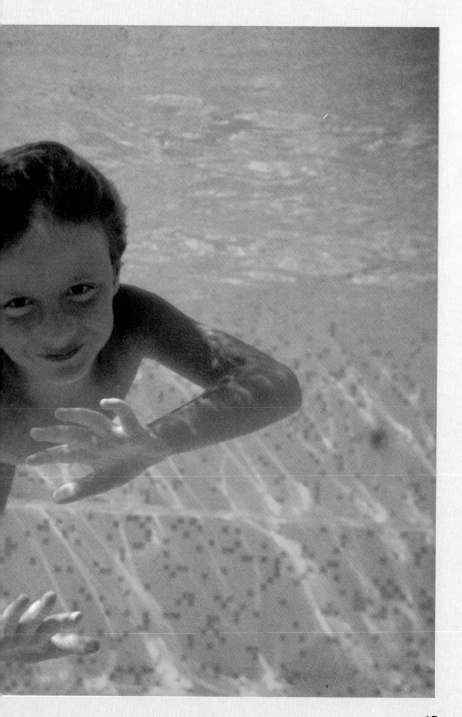

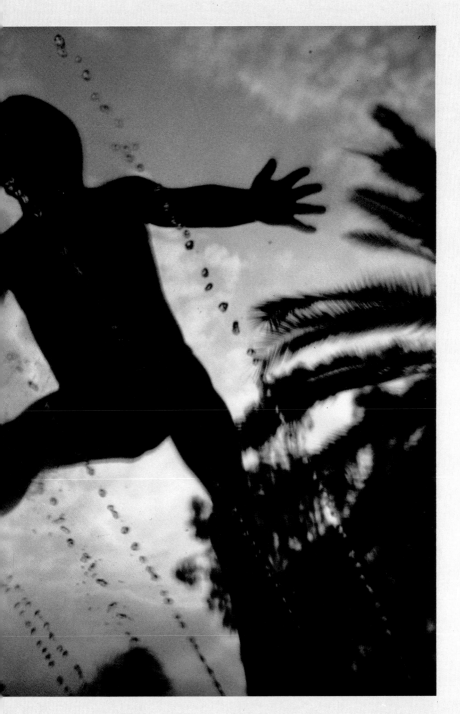

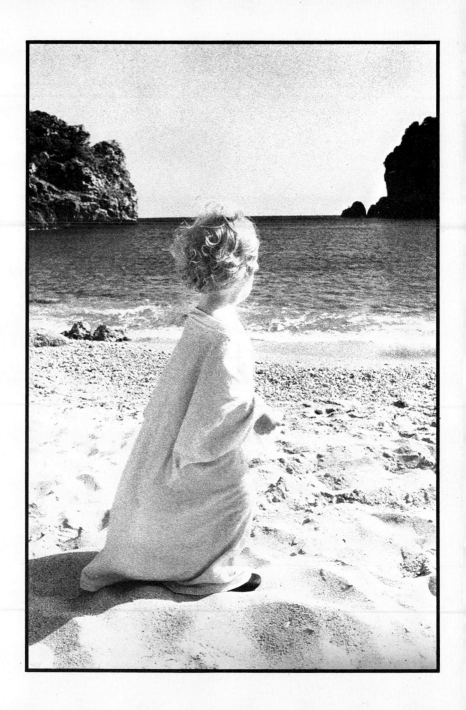

Introduction

My fascination with photographing children started with the pictures I took of my wife Michelle and our first-born son Nicholas at his birth in August 1964.

For the first few years I shot almost entirely in black and white, as a hobby far removed from the rather hard reportage photography I was shooting for *Paris Match* and *Time-Life* at the time. I took pictures constantly and photography became therefore very much a part of our family's way of life. Many of the pictures in this book are the result of this way of life rather than any special professional skills on the part of the photographer.

The fact that my children and their friends at a very young age became used to seeing me with a camera constantly in hand made them act quite naturally – or in fact not act at all – when the camera was around. A camera should be a piece of household equipment like a video recorder or a hi-fi that can be used effectively by any member of the family.

Many of the ideas and choices of clothes for the pictures came from Michelle (now a photographer herself), so recording the lives of our children became very much a joint project – one that we enjoyed immensely.

My photography of children branched out when I started shooting covers for *Parents* magazine in Paris, on the recommendation of a *Paris Match* art director who had spotted my kids' pictures at my studio.

From then on I have shot many assignments for magazines, advertising agencies and television involving children and this book is an opportunity to share with you the knowledge I have gained so far.

I'm afraid that there's no escaping from the fact that it's impossible to take good shots of children without sound photographic technique and total familiarity with the equipment – to the point where the process of taking pictures becomes almost automatic. However the technique of photographing children has to be discussed in relation to the circumstances in which the pictures were taken – the whys as well as the hows, if you like.

The captions to the pictures in the book explain not only how but also why I took the shots, if the girl knew she was being photographed, if the little boy was photographed before or after school, had the baby eaten first or just woken up? Was the picture set up or just reportage? Was the kid dressed that way or did I plan the clothes? What did I actually say to the child? Did I know the children or were they strangers? And so on.

The new technology introduced into photography in recent years has tended to intimidate photographers rather than simplify their job of taking pictures. This book is an attempt to de-mystify equipment and point a way through all the 'hype' to finding the ideal camera for the job and to help you save money, rather than spend it.

The photographer who buys camera gear as a form of jewellery should stop reading right here; this book is not for you. It's for people who are serious about wanting to take better pictures of children, either their own or other people's, as a family record or professionally. I'd like to recommend the photography of children not as a hobby or a profession but as a way of life.

John Garrett

John Garrett was born in Melbourne and has been based in London since 1966. He is co-author of one of the world's most successful photography books, *The 35mm Photographer's Handbook*, as well as *The Travelling Photographer's Handbook*. His international reputation as one of the finest photographers of children is based on 11 years' experience of photographing his two sons and their friends, assignments for magazines such as *Paris Match*, the French *Parents*, *Time Life* and *The Sunday Times* as well as numerous advertising campaigns.

Before we take a look at the photographic equipment and the technology that has been developing so rapidly in recent years, let's first consider the basic principles and functions of the camera.

A camera is simply a light-tight box with a piece of film at one end and a hole at the other. Light enters the hole and strikes the film, forming a photographic image. Added to the box must be a viewing system to enable the photographer to compose the picture, and a lens to focus the photographic image on to the film (reversed from side to side and upside down).

As the camera developed, film transporting devices, reflex viewing and built-in meters were added. But the greatest advances came with the electronics revolution. Auto exposure, programming, auto focusing, autowinds, motor drives, etc., are added features making it easier to take correctly exposed, in-focus photographs. But if you want to take your photography a stage further and make more interesting, exciting pictures you must first understand and use the basic elements of the old magic box, and apply the knowledge to your own super, new, auto electronic magic box.

The 35mm camera is ideal for photographing children because of its speed of operation, compactness, great versatility and potential for taking high quality pictures.

We have a choice between two ranges – the auto focus (AF) and single lens reflex (SLR). Firstly, the auto focus, auto exposure, auto rewind camera (AF) – represented here by the Nikon AF (most major manufacturers have a competitive model in this range). The AFs are very easy, *almost* foolproof, to use but you can't change their lenses and you don't view through the lens. They are great snapshot cameras.

The single lens reflex cameras are the best for photographing children. They have an enormous range of accessories and features and an equally enormous price range. Choose an SLR with an auto exposure facility and exposure compensation (override on the auto).

In this book I refer mostly to Nikons for the simple reason that I have used them for 20 years. However, all the major manufacturers have similar cameras of high quality in every range.

The modern 35mm camera is a wonderful piece of machinery but don't get carried away and think you've got to invest in all sorts of fancy equipment, or that the equipment will take your pictures for you. Great pictures can be and have been taken ever since photography began, on the simplest of cameras.

There are two mechanical devices to control the amount of light striking the film. Inside the lens is a diaphragm – an adjustable aperture which controls the volume of light entering the camera. There is also a shutter, a movable protective shield, either in front of the film or inside the lens, which controls the length of time that light has to expose the film. The aperture controls depth of field, i.e. the amount in front and behind the permit of focus that is held sharp and the shutter controls movement. A subject moving across in front of the camera is also moving across the film. A slow shutter speed will result in a blurred image, a fast shutter speed can 'freeze' the subject. Understanding the job of the shutter and aperture, and their ability to control movement and depth of field, is the most important step towards creative photography.

The modern SLR: Nikon F-301: USA Nikon N-2000

(1) Memory lock
Useful when the main subject is off-centre or if there is a great difference in brightness between subject and background. Take reading off the subject by lightly pressing the shutter button, then while holding down the memory lock recompose and shoot.

(5) Self timer button
You may want to jump into the shot yourself or allow time for the camera to steady on the tripod before a long exposure. The light (2) will flash, the camera will bleep for 10 seconds after you push the lever and the shutter will then fire.

(2) Remote control terminal
For when you and the camera can't be together, e.g. self portrait.

(3) Film speed ring
When DX coded films (most are) make contact with the DX contacts in the camera, the auto metering system is set automatically on the correct film speed.

(4) Shooting mode selector
P (program) and PH1 (program high) refer to the exposure setting. Set your lens on the minimum aperture (f16 or f22) and the camera automatically selects the correct combination of shutter and aperture. The PH1 selects the faster shutter speed possible for the given lighting situation. A is the auto setting which is aperture priority. You set the aperture you require and the camera automatically selects the matching shutter speed. The shutter speeds are for manual shooting. Check your instruction book.

(6) Exposure compensation dial
An essential facility on auto cameras, enabling you to override the auto. You can over- or underexpose up to 2 stops in steps of ⅓ stops for difficult exposure situations or when you want an exposure that is not just an average. (Auto cameras can only give you an average correct exposure which you often don't want.)

27

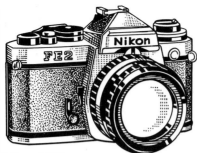

Nikon FE2
One of the best 35mm SLR cameras ever made. Light, but strong and reliable. Can be used on auto (aperture priority) or manual. It has a maximum shutter speed of 4000th second and will synchronize with flash up to 250th second. The metering system on auto is excellent. I prefer its shutter speed indicator needle in the viewfinder to the LED readouts of most electronic cameras. You can see exactly what speed the shutter is taking – on auto electronic cameras have an infinitely variable shutter, i.e., they don't just shoot at 1/25th or 1/250th but anything in between, say 1/135th if the meter says so. The LED displays the closest number, i.e., 1/125th.
The FE2 is not the most expensive in the Nikon range but it is a favourite tool of mine.

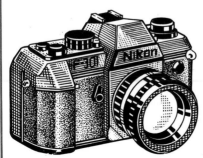

Nikon F-301 (USA Nikon N-2000)
A leader in the high-tech race. It has a dual program system, auto and manual facilities. The auto film wind is built in and can take up to 2.5 frames per second and includes auto film loading. This camera has all the technology and all the override possibilities – it leaves you in charge. A great camera for photographing children.

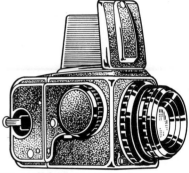

Hasselblad
A 6 × 6cm SLR camera from Sweden. Beautifully made, with a great range of accessories. I often use it for formal studio portraits on a tripod. Very expensive, it is a favourite of many commercial photographers – the square format is interesting.

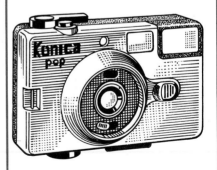

Konica Pop
A useful manual focus, auto flash pocket camera. Well made, it produces high quality, sharp pictures. A good extra family camera – the children can use it too. About the

same price as many instamatic and disc cameras but producing infinitely better results. Great value.

Nikon FM
Cheapest of the SLR range. Auto exposure but no override system, except altering the ASA or ISO rating and an exposure composure button which increases exposure by 2 stops – for backlight etc. A good first SLR camera. Excellent value.

Nikonos V
A unique underwater or adverse conditions camera. It's impervious to salt water, sand, rain or snow. Perfect for the beach. It has auto or manual exposure and TTL metering for flash, plus a good range of lenses. I use it as my on-the-beach and around-the-pool (and in-the-pool) camera. I never go on holidays without mine – a great addition to your main camera. Good value.

Nikon AF
One of the many AF models on the market. It has auto film wind and rewind, auto focusing, auto programmed exposure control and auto exposure flash control. A great little camera for when you can't manage the camera bag – shopping with the children etc.
In very low light the auto focus works well. It is controlled by sound waves rather than light (sonar focusing). Read the instruction sheet *carefully*, to know exactly in what area of the frame the autofocus is focusing and the auto exposure is taking its exposure from.

Snapshot cameras

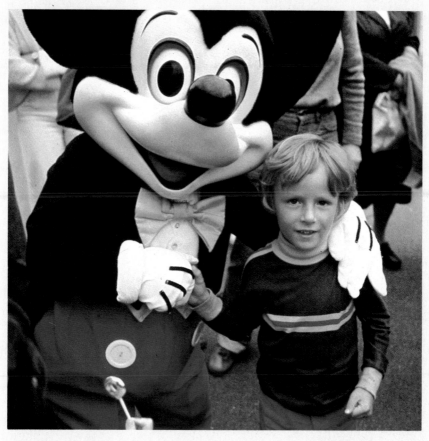

Snapshot cameras:
It's all too easy to get carried away by the latest electronic camera or the longest lens – we all do. But children is what it is all about. Over the years I've captured many precious family memories on simple snapshot cameras.

(Above)
Micky and Nicky in Disney Land – just a family snap, but we love it.
Nikon AF: Ekta EPR

(Right)
Matthew flying past me in his new Captain Marvel underwear. Shooting from ground level made the picture more dynamic.
Nikon AF: Ekta ER

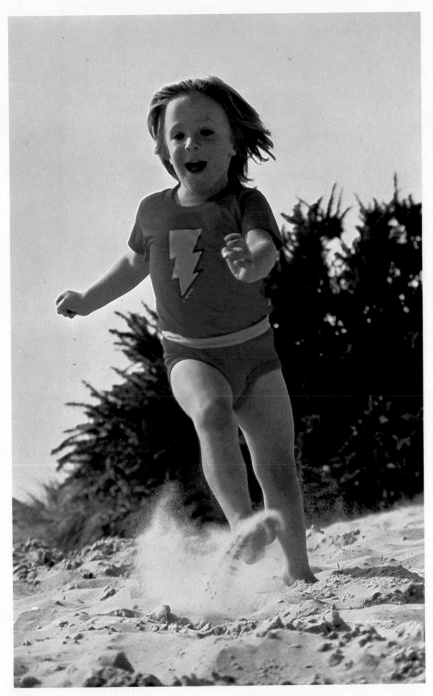

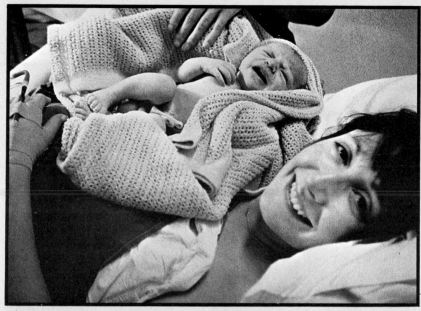

Michelle and Nicholas, two minutes after he was born. I carried the camera in my pocket, not sure whether the hospital staff or my nerves would allow a picture. A wonderful family memory.

Canon dial. F.HP5: print gr.3/faces shaded

Nicholas in winter, wrapped up like an SAS raider.
Canon dial: F.HP.5: dev gr.4/ straight

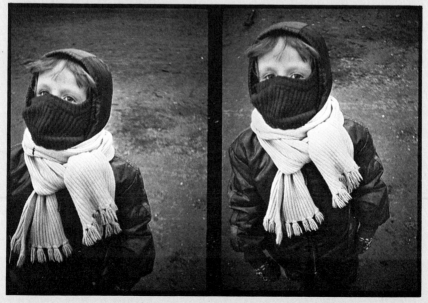

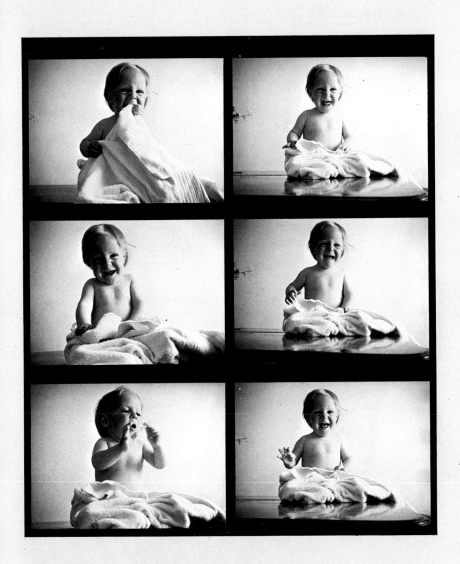

I sat Matthew (with Michelle ready to catch) on a table, against a white wall. Light was streaming through the window. Shot from table level looking up. A sequence can be stronger than a single frame.
Canon dial F.HP5: dev Microphen print gr.3/straight

Taking a picture

Make sure that you are *thoroughly* familiar with your equipment. Pick up the camera in spare moments and practise without film.

A common fault of most inexperienced photographers is to leave the subject too small in the frame – be bold, fill the frame.

Good photography is as much a problem of eliminating the ugly as finding the beautiful. Search the viewfinder for any 'nasties', e.g., a pole coming out of the child's head, or beer cans on the ground. Use the preview button. Rubbish often escapes notice till you see it in sharp focus.

Most importantly *always* have your camera loaded and be aware that the best picture of your life may pop up any time. If well prepared, you can be feeling relaxed and so will the children. Take it easy and enjoy yourself.

Holding the camera

Most out of focus pictures are caused by camera movement – by not holding the camera steady, rather than inaccurate focusing.

I see so many people taking pictures who are holding the camera incorrectly and are not solid and balanced on their feet. Inevitably, they move the camera during exposure and the result is a blurred picture.

Don't be frightened of the camera. Grab hold of it firmly. Think of yourself as a tripod (or perhaps bipod) and as if firing a gun, squeeze the shutter smoothly into the camera – don't stab at it with your finger. Hold your breath at the moment you push the button.

When you are forced to use a shutter speed slower than 1/30th second use a tripod or monopod to hold the camera steady.

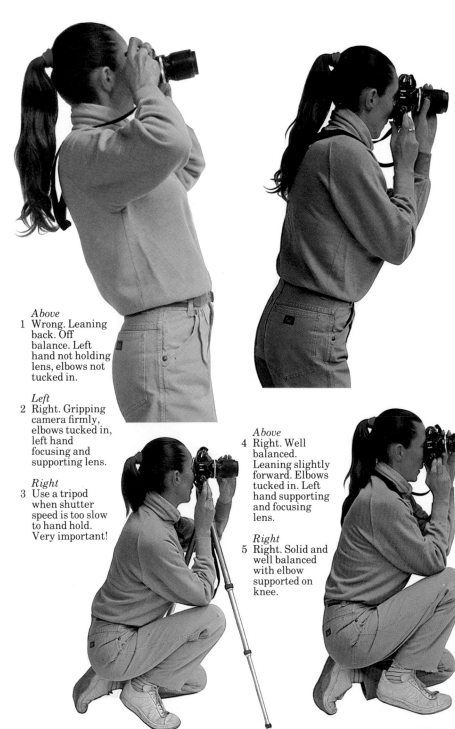

Above
1 Wrong. Leaning back. Off balance. Left hand not holding lens, elbows not tucked in.

Left
2 Right. Gripping camera firmly, elbows tucked in, left hand focusing and supporting lens.

Right
3 Use a tripod when shutter speed is too slow to hand hold. Very important!

Above
4 Right. Well balanced. Leaning slightly forward. Elbows tucked in. Left hand supporting and focusing lens.

Right
5 Right. Solid and well balanced with elbow supported on knee.

The advertisements for all those masses of photographic goodies are confusing; this spread is meant as a guide through the maze to find a compact all round kit that will cope with most situations you will encounter when photographing children.

* Camera

Select an SLR camera with auto exposure, exposure compensation facilities and manual settings. One with a built in auto wind (e.g. F-301) or one that will accept a meter drive (e.g. FE2).

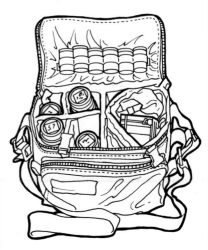

* Camera bag

Don't save money by buying a cheap bag. Expensive equipment deserves good protection. A good bag is very important. Choose one both with handles and a shoulder strap. A soft bag is more comfortable to carry than a metal case. Buy a generous size bag – a bag that is too small is a pain. The Lowe Pro Elite III is excellent. It holds two camera bodies, four or five lenses (depending on size), films, filters, a flash and cleaning kit. The compartments are movable to suit each individual's equipment and it's waterproof.

* Tripod

A very important purchase. Must combine strength and lightness. The smallest Gitzo is the best small tripod on the market. Its lowest height is very useful for children, its maximum height is eye level. Will fit easily into a suitcase.

* Camera cleaning kit
Impregnated lens cleaning tissues;
washable lens cloth; stiff brush for
cleaning off dust, sand etc.; set of
small screwdrivers; cotton buds.

* Spare batteries
Never be without spare batteries for
every piece of equipment.

* Torch
Miniature torch for checking camera
settings in low light.

* Cable release
For long exposures.

* Buddies or Blu-tack
For sticking gelatine filters on back of
lenses, a picture on a child's bedroom
wall and many other uses.

* Reflector
Rosco space blanket (6ft × 3ft, folds to
5in × 3in). Gold one side, silver the
other – invaluable in bag.

*** Lens pouch and chamois leather**
For extra protection of camera and
lenses when travelling.

*** Swiss army knife**
An invaluable accessory. I always
keep one in my camera bag.
Corkscrew and bottle opener are also
useful when children 'drive you to
drink'.

*** Lenses**
The big decision. I suggest a 35-
105mm zoom (or similar length) with
macro facility for most normal
situations, and an 80-200mm zoom to
look into 'the world of the child'; it's
the lens I use most. A 24mm wide-
angle lens is fine for interiors and
exaggerated perspective
compositions. Most shops include a
50mm normal lens in the deal, which
is useful to use as your large aperture
(usually f2 or faster) lens for low light
conditions.

*** Jeweller's screwdrivers**
Invaluable on holidays. Screws only
come loose hundreds of miles away
from the repair shop.

*** Filters in pouch**
Pouch by Nikon fits 6, 52mm or
72mm filters; very compact.

*** Flash gun**
A TTL hand flash, dedicated to your
own camera model, with tilting head
for bounce flash (see Hand flash).

*** Lens hoods – rubber**
Preferred because they pack smaller
than the metal kind.

*** Kodak film bag**
Plastic, insulated and very cheap.
Useful on holidays and for very hot
and very cold conditions. Will float!

*** Extension cord** see Hand flash

All outstanding photographers have a checklist that is second nature to them, because that is what *consistently* good photography is all about – a sound routine and good habits. So memorize this list and check, check and check again – it's the only way.

1 CHECK – the correct programme

2 CHECK – shutter speed

6 CHECK – there is not hair trapped in shutter

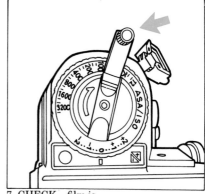

7 CHECK – film is being taken up, rewind lever should rotate as film winds on

FUJICHROME
400 D
FOR COLOR TRANSPARENCE

10 CHECK – the correct film is loaded

11 CHECK – always rewind when you have finished the roll

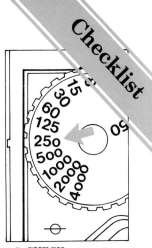

3 CHECK – ISO
(ASA) film setting

4 CHECK – exposure
compensation dial is
correct

5 CHECK – correct
shutter setting for
flash

8 CHECK – film is
wound on to the take-
up spool

9 CHECK – the
camera is locked

12 CHECK – lens
elements are clean

13 CHECK – correct
filter being used

41

Lenses

Lenses of different focal lengths have of course different angles of view, i.e. a wide-angled lens such as 15mm covers a span of 110 degrees and an 800mm lens 3 degrees.

Apart from selecting a wide angle lens to 'get more in' or a telelens to 'get closer to' a subject, the creative decision to be made when selecting a lens is based on its ability to control perspective and depth of field (depth of focus). The wider the angle of a lens the greater is its ability to exaggerate perspective. The longer the focal length of the lens the greater is its ability to foreshorten perspective.

Also, the wider the angle of the lens the greater is its depth of field, and the longer the lens the smaller is its depth of field.

Experienced photographers all have their favourite lenses, whose qualities suit their style and personality, and appeal to their design sense and way of looking at things.

In recent years the lens manufacturers have made great strides. Resolution (sharpness) has improved, colour rendition is better; lenses focus closer, have larger apertures (can shoot in lower light) and are physically lighter. There has been great improvement in the range and quality of zoom lenses – the most useful lenses for child photography.

This is a good time to be taking pictures with the marvellous range of lenses at our disposal. But remember that some great photographers of the past worked entirely with one lens – it's the eye behind the lens that *really* counts.

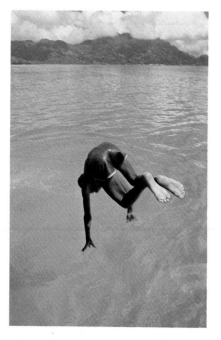

The extreme wide angle enabled me to get close to the boy and so look down on to him against the sea. He is so physically close (2 metres) that the perspective exaggeration has emphasized his glowing white feet. *20mm: Fi 81A/ ER64/exp auto*

Fishermen in the Seychelles. The 18mm lens has completely altered the perspective, changing the relative sizes of the elements in the picture. The big rock is bigger in the foreground and the boys smaller than in reality, the small rock appears further away and the clouds have exploded out to the edge of the frame. I have made my own graphic design out of a real situation. *18mm/Ekta 200 @ 250/F81C + 5M gel/ exp/bracket tripod*

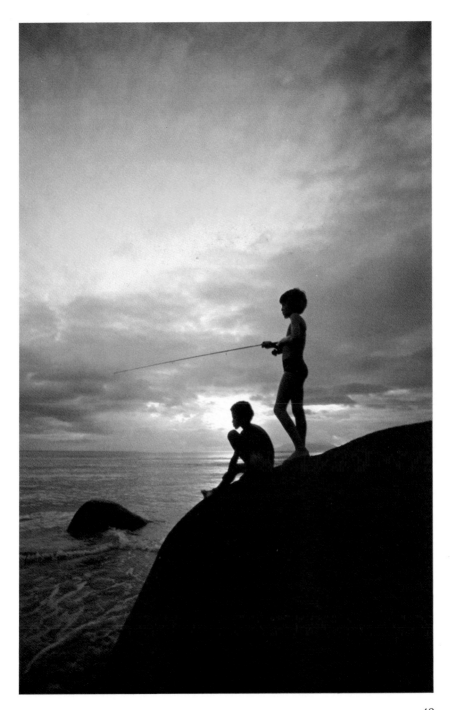

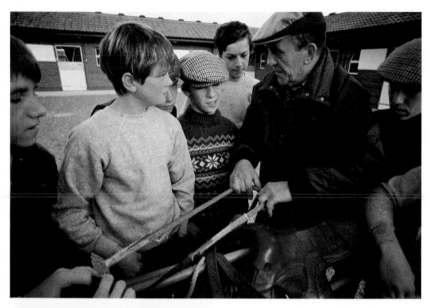

(*Above*)
The 24mm lens has enabled me to 'get inside' the conversation between the boy jockeys and their teacher and really see what's going on – an important job of the medium wide-angle lenses.
24mm/Ekta EL 400 @ 500 ASA: exp auto

A game of backgammon in Turkey. The 28mm lens has made the men bigger and Matthew smaller than to the eye. We can see the beer, the board and a café full of men in the background. The resulting composition is strong.
28mm/FA2/Ekta EN 100/exp auto

(*Right*)
Classic job of the wide-angle – exaggerating perspective. The clouds explode out to the edge of the frame.
24mm/red filter/ HPS dev Microphen print gr.4, road shaded

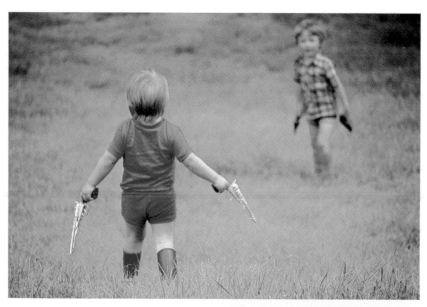

The development of zoom lenses has been a great boon for the photographer of children. They reduce the number of lenses we need to carry. We can work very fast, changing focal length without having to change lenses and, very importantly, can frame pictures accurately without having to change position, which often distracts the children's concentration. I have a 35-105mm zoom with macro facility and an 80-200mm zoom. I use them for 70% of my kids' pictures.

This series of Matthew with the cowboy guns is a good example of the potential of the zoom. Each framing – (*top*) on 80mm, (*right*) on 150mm and (*far right*) on 200mm – has made an entirely different picture out of the same scene, all made within seconds of each other. This would be impossible on fixed focal length lenses.

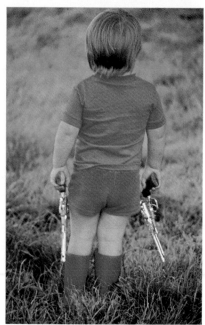

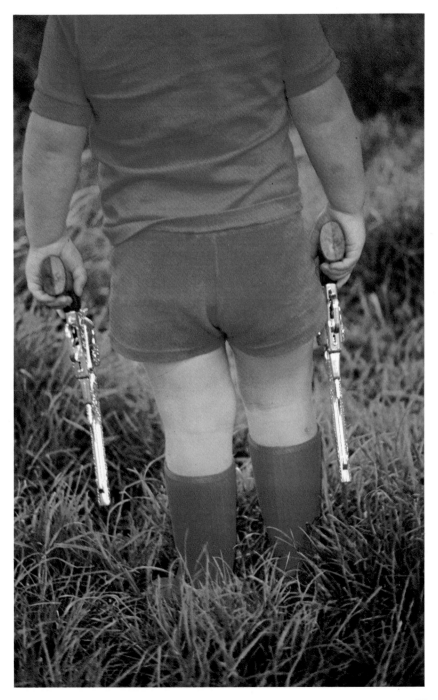

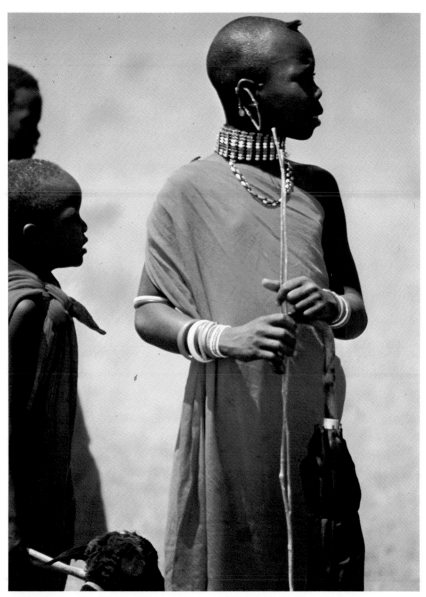

The 300mm lens has lifted the girls off the background (telephoto lenses have a narrow depth of field) turning the grass into a soft undistracting colour background. It has also brought the figures closer together than they really appeared. The topknot on the eleven-year-old Masai girl's head is a sign to the world that she is the only child her mother has left and asks that everybody she meets takes care of her. I observed her without being observed (20 metres away). *300mm/Ekta ER/ F81^A/exp. auto f.5.6 @ 500th*

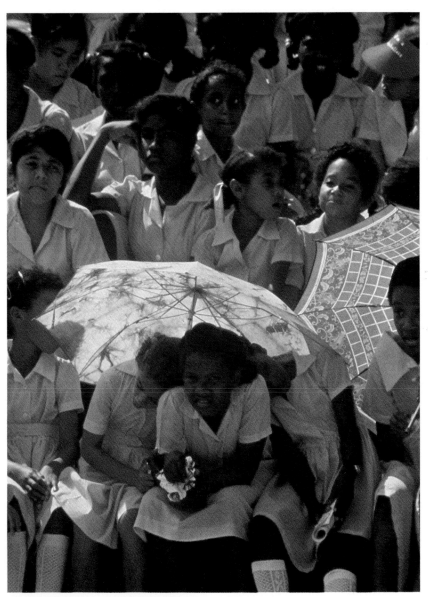

Schoolgirls in the Seychelles. The 560mm lens (including teleconverter) has done the opposite job to the wide angle. It has compacted the perspective. Each row of girls appears to be almost pasted on to the row in front making a wall of girls and colour. The telephoto also allowed me to observe without disturbing the subject (shot from 50 metres away). *400 + 1.4 teleconverter/Ekta EPR/F81B/exp auto @ f.8/ tripod*

Special lenses

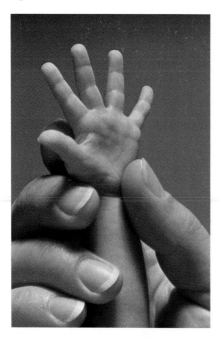

This studio shot of Matthew and a man's hand were shot with a specialist micro lens, but could have been shot on a zoom with micro facility. The micro (some call it macro) helps you isolate special little observations. *105 Micro/F81B/ Ekta EPR/light-studio flash/exp f.11/tripod*

The mirror-constructed long lenses produce rings of out-of-focus highlights in 'doughnut' shapes. They are very compact and light for their focal length – and *great value*. They do have smaller (fixed) apertures than conventional lenses but you can overcome this disadvantage by using a faster film. *500mm mirror/ Ekta ED 200/exp auto/tripod*

Exposure

A correctly exposed photograph is one in which the important feature or focal point (that *you* consider important) is exposed for maximum detail.

Cameras with auto exposure and programs have been ingeniously designed to give an average correct exposure in most average circumstances, and that's great. But often you don't want an average. You may wish to expose for the highlights or the shadows. You may wish to shoot a darker than normal picture or a wishy-washy light picture just for creative effect.

As long as you know what result you want and you are totally familiar with the metering system of your camera (study all the manufacturer's manuals) there is no problem – you just tell the machine what to do.

There are two basic types of auto exposure in use on modern cameras. Aperture priority in which you set the aperture and the camera automatically sets the shutter to match. Shutter priority is when you set the shutter speed and the camera alters the aperture to match. Both are equally effective. When set on program the camera takes over, setting both aperture and shutter and also deciding on which is the main feature in the picture.

The auto cameras can be overridden by either the exposure compensation dial or by altering the ISO (ASA) setting, i.e. if you change 100 ASA (ISO) setting to 200 ASA you effectively halve the exposure (under expose by one stop; see Aperture).

The following pages show how to solve the main exposure problems, using the sophisticated technology the camera manufacturers have developed so that you achieve the results you see in your 'mind's eye' – not just the average snap shot.

Exposure meter
When an exposure reading is taken the meter displays a range of shutter and aperture combinations, all of which will make correct exposures. The 4,000th second has an equal exposure value to 15th second @ f22. The combination you choose depends on whether the aperture setting or the shutter speed setting is your main priority (see Aperture and Shutter).

1 Study your results and decide what exposure change may, if at all, improve them.
2 When exposing for black and white or colour negative *don't* underexpose.
3 Study your camera manual carefully.
4 Remember exposure density is a matter of personal taste. A transparency that I consider too light (too thin) may be the one you prefer – consistency is the important thing.
5 Exposure density is a creative decision not a technical one.

A yellow house in the Seychelles. This is an example of what I consider a good average exposure. All the colours are well saturated. Film manufacturers would consider this to be ½ stop underexposed (see film) but I like rich strong colours.

It's vitally important that you are aware which system of TTL metering your camera uses. I personally prefer a 60%/40% system for photographing children. The 80%/20% weighting incorporated into some cameras is too specific. The 60%/40% weighting takes a more general reading and produces better all-round exposures.

Study the exposure meter illustration and follow it carefully. An understanding of the basic principles is essential.

Exposure 2

1 Automatic multi-pattern metering reads each segment, then decides on an optimum overall exposure.
2 60% – 40% centre weighted metering; the reading is biased towards the central area (some cameras also 80% – 20%).
3 Spot reading, the exposure is taken from the centre.

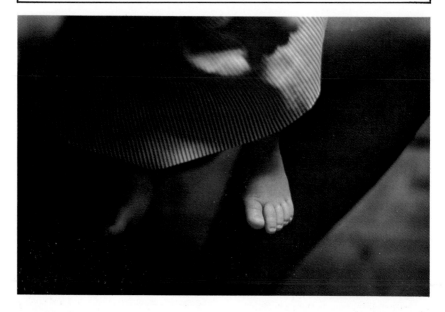

Samantha's foot. This is one of the trickiest exposure problems – a small light object in a large dark background. The camera's meter will try to expose for the large dark background area, therefore overexposing the foot. I set the camera to manual, came close and took a reading off the foot, then came back, composed, and made this picture.

35-105 zoom @ 35mm/Ekta ED/exp 125th @ f5.6

The light is pouring into the camera meter and on auto the camera underexposed the shot (*right, above*). I overexposed (+ 1½ on the exposure compensation dial) on the second shot (*below, right*), and Jill's face is now correctly exposed. Most auto cameras have a backlight compensation button. *135mm/FKR3/Ekta ER/exp auto + 1½*

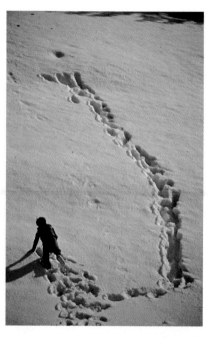

The shot of Nicholas (*above, right*) is typical of a problem with auto exposure. The meter has exposed for detail in the snow. Nicholas is underexposed and there is no colour in his clothes. In this case it works well graphically. In the shot of Matthew (*above, left*) the camera has exposed correctly for the figure because he is nearly filling the metering area, and there is less snow area to affect the exposure. Even then I was set at +⅓ stop on exposure compensation dial. Watch out for this situation.
Above right: 35-105 zoom @ 80mm/ Ekta EPR/exp. auto
Above left: 80-200 zoom @ 150mm/ Ekta EPR/FKR3/ exp auto +⅓

(*Right*) This shot of Matthew on the staircase was exposed for dramatic effect. The stairs appeared lighter to the eye. This shot was exposed for the absolute highlights. I shot several exposures. One on normal, one at − 1 stop, one at −1½ stops and finally at −2 stops. This picture is the −2 stops exposure.
2.4mm/Ekta.EN/f2/ exp auto −2

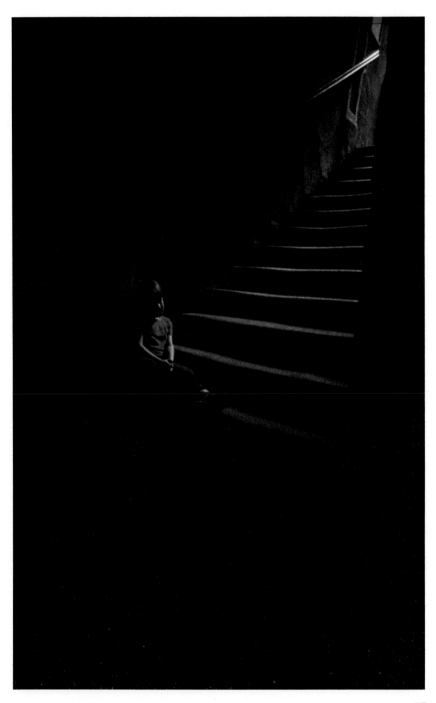

Aperture

The aperture of the lens controls the volume of light entering the camera and the depth of field of the photograph (see diagram). The size of the aperture is calculated in f stops, which are fractions of the whole, therefore the higher the number the smaller is the whole, i.e. f.16 (stopped down) may be the smallest aperture of your lens and f.2 may be the maximum (wide open). Each time you stop open or down one stop you double or halve the amount of light entering through the lens, i.e. f.11 is half of f.8 and f.5.6 double f.8.

The decision of which aperture you use is dependent technically on how much light is available and creatively on what area of the picture you require to be in sharp focus. If you just want the child sharp against an out-of-focus background you open up to a large aperture (i.e. f.2); or if it's important to see the child's surroundings clearly also, you need to stop down for a greater depth of field (depth of focus), i.e. f.11 or f.16. Which

aperture you choose is dependent on which focal length lens you are using (see Lenses). Also, because your aperture and shutter are inseparably linked to control exposure, your aperture priority is also dependent on what shutter speed is needed to keep the camera still and the child sharp (see Exposure).

If you open up one stop (doubling the light) (then you must halve the speed (see Exposure) to maintain the same exposure value.

(Below)
An example of shooting wide open (large aperture). Nick's hand is sharply emphasised but you can still just see that it belongs to a little boy.
35-105 zoom @ 60mm/Ekta EN/ F11A2/exp. auto @ f.3.5

(Right)
I wanted to see the footprints, Matthew and his destination all sharp. So I stopped down to f.16. Stop down when you want to be 'descriptive'.
28mm/Ekta EN/F polar/exp. auto @ f.16

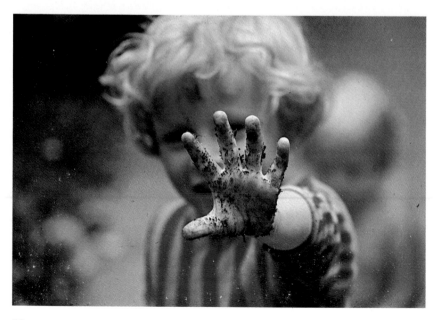

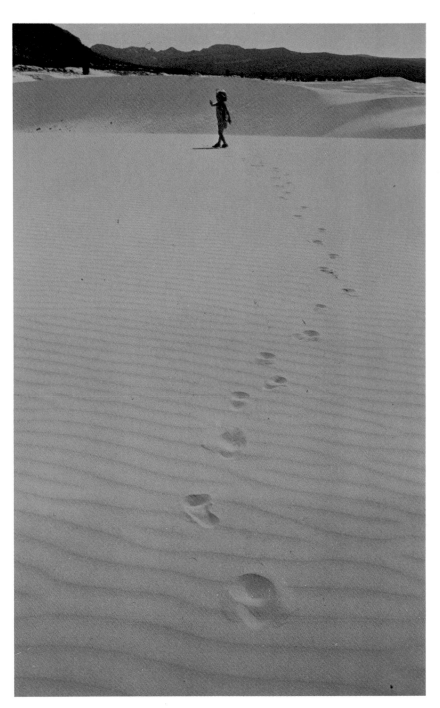

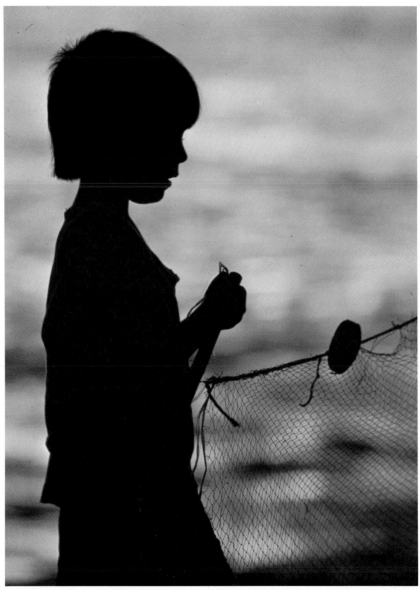

(*Above*)
Seychelles
fisherboy. I shot
this silhouette on a
300mm lens wide
open. The boy
stands out clear
and sharp. The sea
has become a
coloured
background. At
f.11 the sea would
have been sharp
and distracting.
*300mm/KD 64/F
KR3/exp auto/tripod*

(*Right*)
Here I have also
shot wide open but
focused on the
skier. The
foreground has
become a soft
colour frame.

Both these shots
demonstrate the
influence of the
aperture on colour.
*80-200 zoom @
180mm/Ekta
EPR/F KR3/exp
auto +¹/₃ @ f.4*

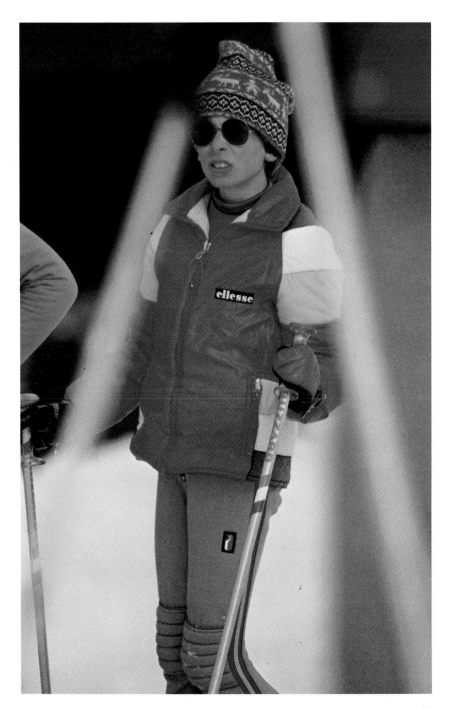

Shutter

The choice of shutter speed is dictated by the desire to control movement and the need to hold the camera still.

You may wish to allow the movement to blur across the film with a relatively slow shutter speed (relative to the speed of the movement) and so record the *feeling* and impression of movement; or you may wish to freeze movement so you can observe the details sharply defined – the position of arms and legs, the facial expression and so on – observations impossible for the naked eye. The next three pages illustrate the various uses of shutter speed.

The waterfall is blurred into a milky white flow by using 30th second shutter speed. A fast shutter speed could have frozen the drops of water but the waterfall wouldn't have been as visible against the black rocks. *80-200 zoom @ 110mm/Ekta ED/exp 30th @ f.4.5/camera supported on tree*

This shot has been exposed for the extreme highlights (reading taken off my hand). 1000th second has frozen the water into individual drops. *500mm + 1.4 teleconverter/Ekta ED/exp 1000th @ f.11/tripod*

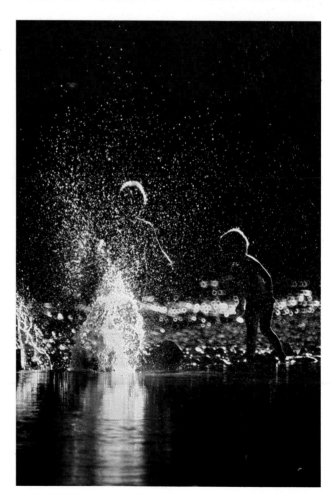

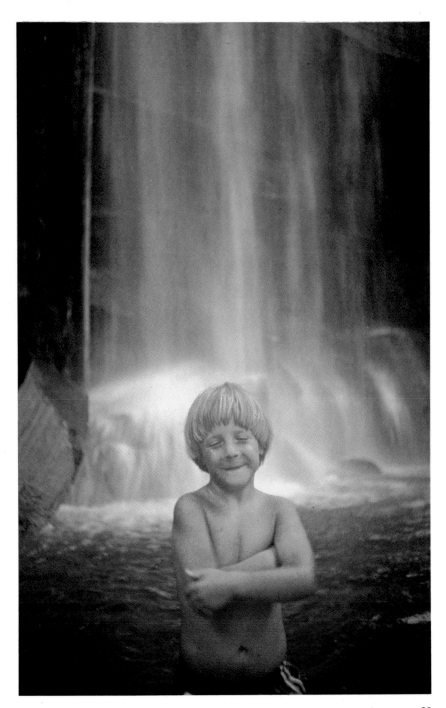

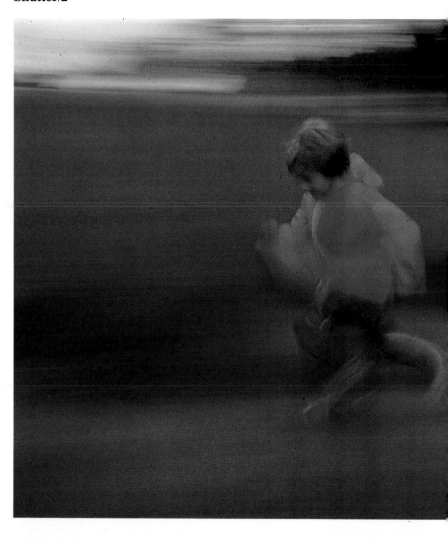

I panned with Matthew as he ran past me and shot at 8th second. This has produced a sweeping blur to the picture – a *feeling* of speed rather than the frozen action I would have achieved on a 500th second. *35-105 zoom @ 50mm/Koda 64/F A2/exp auto @ 8th*

500th second was required to freeze the moment of the boy heading the football. *300mm + 1.4 teleconverter/3m 1000/exp auto @ 500th*

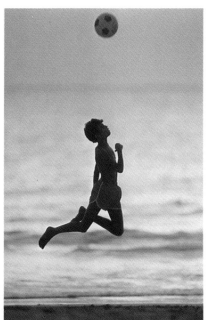

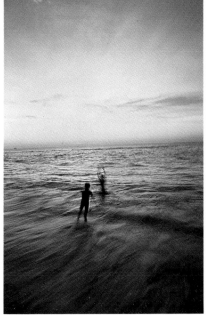

This rather abstract effect of the boys swimming in the sea was achieved by shooting at 1/2 second and letting everything blur. Slow shutter speeds are something of an experiment but a worthwhile one. *24mm/Ekta ER/F 81A/exp auto @ 1/2 second*

I took this picture of Marion in a spin just at the moment she stopped spinning and her dress was still in motion. The shutter speed of approximately 90th second was enough to hold her sharp but to allow her dress to blur. (90th second was set by the infinitely variable autoshutter). *35-105 zoom/Ekta EN/FA2/exp auto @ 90th*

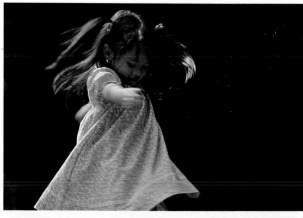

When the boys were jumping towards the camera only 125th second was required to freeze the action (*right*). A 500th was required when they were jumping across the camera (*below*). *80–200mm zoom/ Ekta ED/F A2*

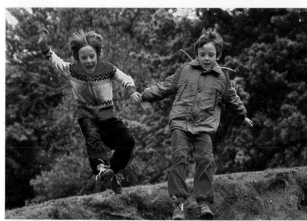

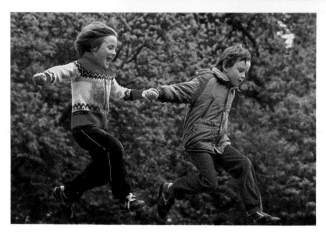

This picture was shot just as the little girl hit peak action. A 125th second was all that was required to freeze the action. If she had been on the way down a 250th would have been required. If I had taken the picture from the side and the swing had been moving across the frame I would have needed 1000th second. *80-200 zoom/Ekta ER F/polariser/exp auto at 125th*

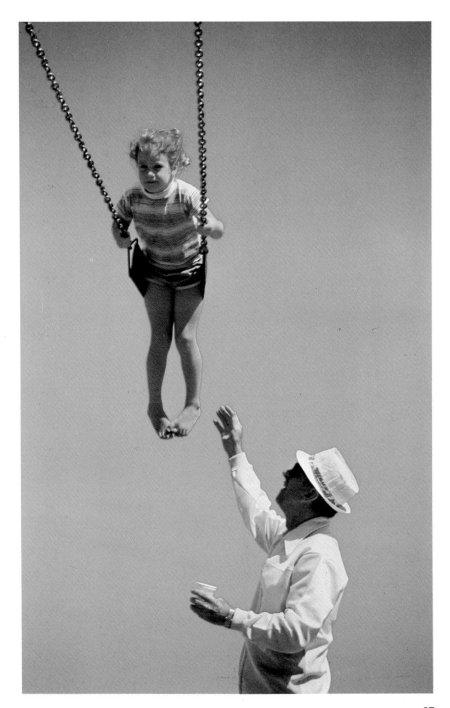

Film

The film manufacturers have made great strides over recent years: colour balance and resolution (sharpness) have improved and they have all introduced a 1000 ISO or ASA range of films (ISO and ASA are measurements of a film's sensitivity to light or film speed and are interchangeable). So we now have a suitable film for almost any light conditions or any visual effect.

If you are serious about your colour photography, I strongly suggest you shoot transparency film. If you shoot negative colour film you put yourself entirely in the hands of the printer – or more likely a machine. You hand over the vital results to someone or something that firstly didn't see what you photographed and secondly has no taste anyway (the machine I mean). Every thing is geared up to churn out the average. All the work of filtration or whatever that you did may be filtered back out by the printer.

Shooting on transparency film allows you to create in the camera – to use the filter *you* want, the exact exposure and the finest framing. Also, there is nothing like a great family slide show – the children love to see themselves up on the screen larger than life. It makes them more involved in the pictures. You can then choose just the very best shots for printing, but now (very important) you have the transparency as a colour guide to be faithfully reproduced by the printer or yourself (see Darkroom).

It is very important to develop a good relationship with your local lab technician. Find the local professionals' lab. Learn the correct terminology. The technician can be an invaluable teacher.

Most films (not Kodachrome) can be uprated – shooting Ekta EL at 800 ISO or ASA instead of the manufacturer's rating of 400 – then

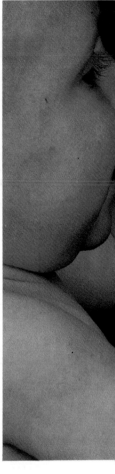

Kodachrome 64
Julian Calder had arrived home from Africa bearded, and Nicholas found it irresistible. A typical example of this range of films – shot in the studio with lots of studio flash – every whisker is sharp and the picture is grain free.
Kodachrome 25/ 105mm/F 81ᴮ/exp f.11

pushed one stop in processing.

You must mark your film +1 or 800 for the lab and never change ASA or ISO ratings half way through the film (unless you are deliberately under- or overexposing a frame or two). When film is 'pushed' its contrast is increased and it becomes more grainy. A general rule to follow is that the slower the film (colour and black and white), the finer is its grain structure and the higher is its contrast and resolution. Also, with colour, the greater is its colour saturation.

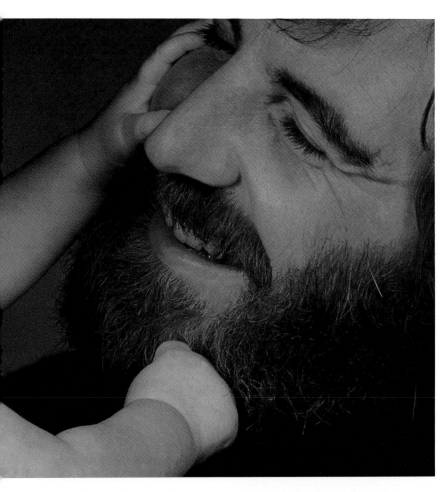

Most professionals are rather conservative when it comes to film. They stay with the films and the lab they know – that's very good advice.

Film groups

Kodachrome *25, 64, Fuji 50D, Agfa RS50*

Kodachrome 64, 25 and 40 (an artificial light film) are the sharpest films on the market. They are grain free. The 25 ASA version produces better skin tones than the 64 but you require lots of light. Kodachrome functions best in clean bright light.

The disadvantages are that all processing must be sent to Kodak, you can't push or pull film and you can't clip test. I sometimes find it too clinically sharp.

Good alternatives to Kodachrome are the Fuji 50D and Agfa RS50 (50 ASA or ISO) – both extremely sharp but they can be lab processed in E6 and can be clip tested etc., giving you more control. I prefer the colour on Fuji 50D to Kodachrome.

I rate Kodachrome 64 @ 80 ISO and the 50 @ 64 ISO for better colour saturation

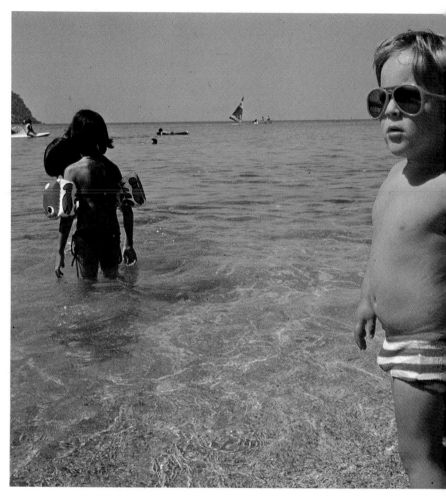

100 ASA Group
*Fuji 100D,
Ektachrome EN
100, 3m100, Ilford
100, Agfa RS100*
This is the most
useful range of
films for
photographing
children. They are
sharp, low grain,
with good colour
saturation. They
can all be pushed
up to 1 stop if you
are short of light.

Fuji and
Ektachrome both
have beautiful skin
tones – Fuji is
especially good in
dull conditions.
This range should
be your best all
round film. Get to
know the one you
prefer (results will
vary with different
labs) and then don't
switch around
unnecessarily.
Ektachrome EN. I

*always rate this
group at 125 ISO
for better colour
saturation.*

Ekta EN 100
For this type of
shot I would never
use any other film
than from this
group. The skin
tones are rich and
true and so are the
blues. The
sunglasses were
not a plant!
*Ekta 100EN/
Nikonos/exp auto @
f.8*

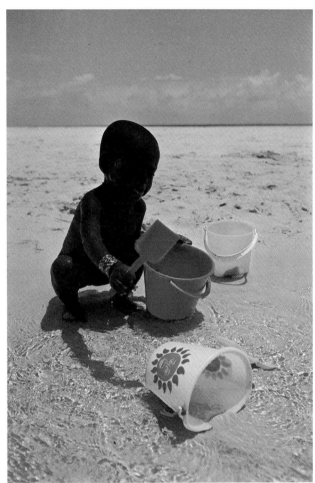

Fuji 100D
This shot of Samadi and her buckets demonstates the qualities of the medium speed E6 processed transparency films. All the colours are well saturated, the picture is sharp and bright. I confess, the buckets were a plant!
Fuji 100D/Nikonos/ exp auto @ f.16

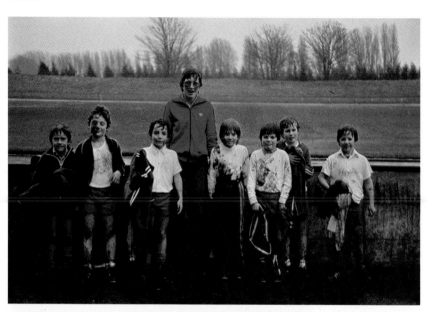

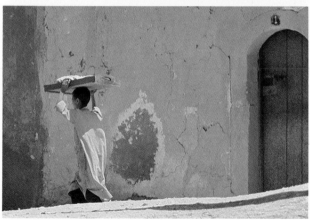

The Vale School football team after the muddiest, wettest, coldest football match I ever supported. The Ekta 400 pushed to 800 has enabled me to capture the memory. This picture wouldn't have been possible on slower film. (The score can't be published.)
Ekta EL400 @ 800 ASA (ISO) pushed ½ stop in process/ 80mm/F A2/exp auto (60th @ f.2)

200 and 400 ASA Group
Ekta ED 200, Agfa RS 200, Kodak EL 400, Fuji 400D, 3m 400
These are the films to use when you haven't enough light to shoot the 100s, either because you need to freeze action or you are shooting on a long lens. The colour is not as saturated as the 100s, the grain structure is coarser and the resolution softer. I always uprate this group – 200s to 300 ASA, 400s to 600 ASA – and process normally. I get stronger colour that way.

Bread delivery in Morocco. I required the extra speed of ED 200 here because I was shooting on a 300mm lens and had to have a fast shutter speed to keep the camera still.
Ekta ED 200/ 300mm/F A2/exp auto

A father and son in a dark forest in the Seychelles. The Ekta EL has held the skin tones very well with the help of a KR3 filter. The fast films perform well in these conditions.
Ekta EL 400/ 80mm/F KR3/exp 60th @ f2

1000 ASA group
Kodak EES P800/
1600, Agfa RS
1000, 3m 1000
Fujichrome 1600
I used 3m 1000 film
for this shot of
Michelle's cousin

Lauren and baby
Tom purely for its
painterly quality.
The large grain
structure and soft
colours helped
capture the
relationship

between the two of
them. I uprated the
film to 2000 ASA
(ISO). This
increased the
grain.
3m 1000 @ 2000
ISO pushed 1 stop

in development/80-
200 zoom/F KR3 +
Softar no. 1/tripod/
exp 250th @ f.5.6/
daylight

This picture would have been impossible a few years ago. I was able to shoot hand held purely by candlelight. Keep a roll of fast film in your bag and look very carefully before you destroy the atmosphere by blasting away with flash.
3m 1000 @ 1500 ASA pushed ½ stop in development/ 35mm/exp auto @ f.1.2

As with colour the black and white films fall into groups.

1 The very fine grain high resolution films: Agfapan 25 (25 ISO), Ilford Pan F (50 ISO) and Kodak Panatonic X (32 ISO). This group are slow films (low ISO or ASA ratings). Beware: they can be too sharp.

2 The medium speed films: Kodak Plus X (125 ISO), Ilford FP4 (160 ISO) and Agfapan 100 (100 ISO). This is a very useful group – they are fine grain and high resolution films but the film speed is practical for most situations.

3 The fast 400 ISO group: Ilford HP5, Kodak Tri X and Agfapan 400. These are the most useful group of films for photographing children. They have a softer gradation (detail in highlights and shadows) than the first two groups. The 400 ISO film speed *is* valuable and the grain is not oppressive – in fact I rather like the grain structure. The film speed can be uprated to 800 ISO by increasing the development time.

4 The very fast Kodak Recording Film 2475 (1000–2000 ASA) and Kodak Royal X Pan film (1250 ISO). Kodak HC 110 developer is recommended for both. Ideal when in very low light or when you wish to experiment with grainy effects.

5 Ilford's XP1 is a dye-based emulsion film that can be exposed at 50 ISO or up to 100 ISO depending on development time given. The processing requires more controlled dark room conditions than the traditional black and white films, however.

The 400 ISO range is ideal for general shots like this boy playing ball at the party. There is grain but it adds to the atmosphere. *HP5 D76/105mm/ exp auto @ f2.5/ print grade 3 left side printed in*

This portrait of Nicholas at two-and-half years shot on 6 × 6cm format using FP4 (160 ISO) is almost grain free. The smooth, textureless quality has captured his glowing skin and big clear eyes without any interfering grainy texture. His expression is so intense because he's looking for his reflection in the lens.
FP4 Microphen dev/150mm lens/ exp f.5.6 studio flash/print on grade 4 exposed during development

Filters

Filtration shouldn't be the great mystery of photography, as the principles are very simple.

Filters can do two jobs: the technical one of correcting the colour balance (or tonal elements in black and white) in less than ideal conditions; and the more creative one of altering the colour balance (or tonal balance) to whatever you would like it to be.

Photographers are often disappointed with the colour of their pictures – usually because the eye and the brain can do what the lens and the film can't. The eye flits about and relays a mass of colour images to the brain which responds emotionally and forms a very different picture from what the mechanical lens and film can reproduce.

The 'mind's eye' is what we try to reproduce on film, not necessarily just what the lens sees. The great pictures of children capture how we feel about children, not just their appearance; and a lot of that feeling is the colour or tone of the image. Filters can control that colour.

A well-filtered picture is not noticeable as having been filtered (unless a deliberate special effect), it just looks right! Filters do what God does on one of his better days – or maybe it's just seeing our children through 'rose coloured glasses'.

Warming Filters

The warming filters are the most important in the photography of children. They are very effective on skin tones and intensify most colours – especially useful in dull, overcast weather. I very seldom shoot without one. I keep a warming filter A2 or 81^A permanently attached to all my lenses because I seldom shoot without one and they also provide good protection for my lenses.

I planned to take some autumnal shots in the park and organised the colour of the boys' clothes accordingly. The 81^B filter (brownish colour) added richness to the colour. But the picture was made by the boys whispering a secret (probably about the photographer). The 81 series goes from 81, 81^A, 81^B, 81^C, 81^D, 81^{EF}, increasing in strength as they go. They intensify most colours. *300mm/F 81^B/Ekta EPD 200/exp auto*

David and Nicholas met at my studio when David was on a modelling job. They looked so great together that I couldn't resist taking some shots. The background is a brown colourama that I sprayed with dark brown pressure pack paint. I used an 81^D filter to strengthen the already warm colours and so that Nick's white skin was not too stark against David's. The picture works well because David had such a natural rapport with babies – they both enjoyed the session. I just recorded it. *F 81^D/80-200 zoom @ 135mm/exp f5.6 with studio flash*

Tungsten Light Filters

There are films on the market that are balanced for tungsten light, e.g. Ekta EPY, Ekta EPT, 3m 640T; but rather than carry more film, it's simpler to carry an 80 A filter that converts daylight film to tungsten light or an 82^C that is half way between the hot colour of tungsten on daylight film and the almost *too* accurate 80^A effect. An FLD filter will correct fluorescent light for daylight film.

Top left – without filter
Bottom left – with 80^A filter

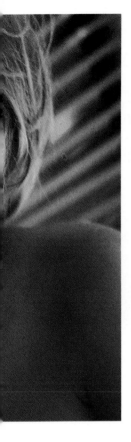

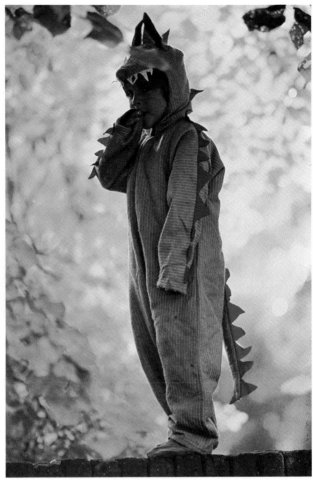

The green light filtering through the trees has intensified the green of Matthew's dragon suit and thrown a green cast on to his face; it's OK here because the whole mood of the picture is green.

Green light was also falling on to Nick's face but I have filtered it out with an A2 filter (slightly pinker than an 81A).

I photographed this little chap (left) on a grey, overcast day in Corfu. The KR3 filter has done its bit of magic – the skin tones are wonderful. The picture of Nicholas (right) was taken on a grey London day without a filter – the skin tones are grey and lifeless. An 81 series or an A2 filter would have done a good job also. The KR series made by the B & W company are slightly pinker than the 81 series and go from KR1½ (close to an A2) up to a KR12 which is so strong as to be a special effect filter. The KRs are not so good on sea and sky – too pink!

The picture below of Nicholas was made without a filter. The snow has picked up the blue from the sky and it looks cold! The skier (above) was shot with a KR6 filter. The snow is a warm white and the colours of the clothes are saturated. You must decide on what emotional feeling you wish to convey in a picture before you 'pop' on a filter.
(Below) 80-200 zoom/Ekta EPR 64/exp auto (Above) KR6/80-200 zoom/Ekta EPR 64/exp auto +1/3

Graduated

Filters that graduate from a colour or tone on one side to clear on the other. They are used to add tone or colour to a chosen area of the picture (by rotating) either for effect or when the exposure range from light to dark is too great for the film to reproduce.

Don't stop down too far, especially on wide angle lenses: the result would be a line across the picture where the colour ends.

Graduated filters can produce very effective or very vulgar pictures depending on how they are used.

The morning sky (right) was white above the trees. I used a colourless neutral density filter to reduce the exposure by two stops in the top third of the frame so that the white sky would no longer distract the eye away from the children silhouetted against the backlit sea. Take the meter readings before you put on a grad filter, otherwise an auto camera will overexpose the shot.
2 stop ND grad/ 300mm/ Kodachrome 64/exp 500th @ f.8/tripod

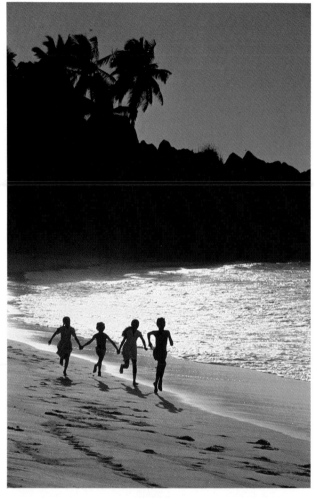

Polarizing Filters

Polarizing filters reduce the amount of light reflecting off a subject, thus increasing the colour saturation and the contrast of the picture in much the same way as polaroid sunglasses, except that with the filter you can 'dial in' (rotate filter) as much polarization as you require.

You need bright sunlight from directly behind you for the filter to work effectively.

I usually underexpose by ⅓ to ½ a stop when using polarizers with wide angle lenses.

The ideal situation (right) for a polarizing filter. The filter has increased the contrast, making the Seychelles sky darker, the cloud brighter and the shadows denser. The scene has been reduced to a graphic design.
F polarizer/24mm/ Ekta ER/exp auto −⅓

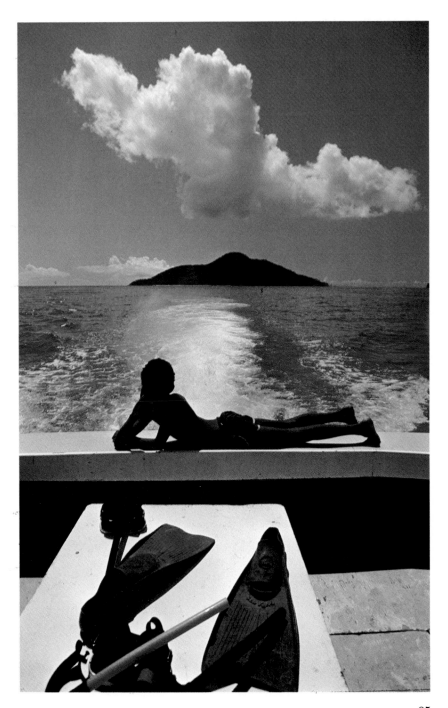

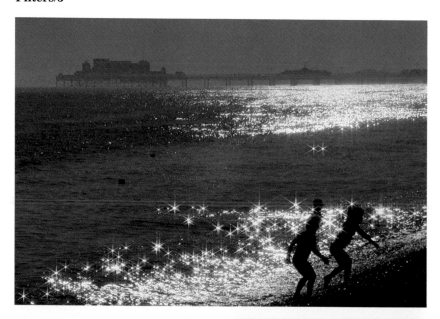

Michelle's view of Brighton, using one of an enormous variety of special effect filters on the market. The star filter only works off a point source of light.

This shot with light dancing on the sea was made for a star filter. Michelle used it to add a little more magic. The underexposure by ⅔ of a stop adds some mystery. *Star filter/80-200 zoom @ 200m/Ekta EN/exp auto −²/₃*

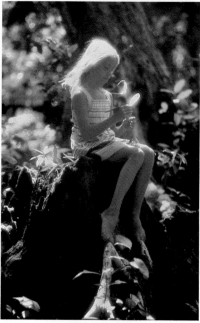

Soft Focus *(Right)* The backlight falling on the leaves and the little girl's blonde hair were made to look even more romantic by the softar filter. The picture captures the 'mind's eye's' view of the scene. The degree of softness is controlled by the f stop you use. The larger the f stop, the softer the effect. *Hasselblad softar 1/35-105 zoom @ 105mm/Ekta ED/F softar 1/exp auto −¹/₃*

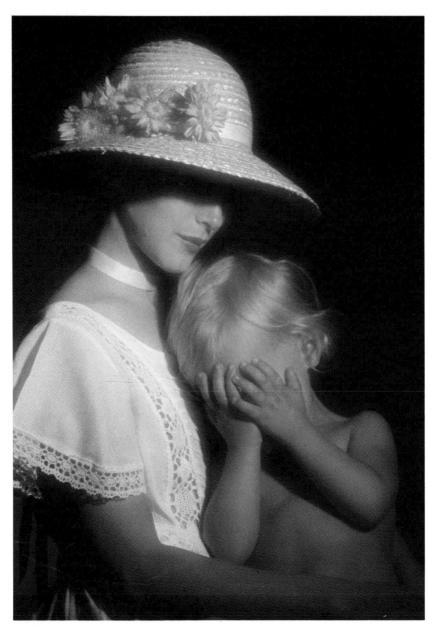

The softar used as a 'cosmetic' filter rather than an 'effect' filter. I often use a no. 1 softar in the studio with the lens at f11. The filter smoothes out the skin tones. There are several makes of soft focus filters. Hasselblad softars with a conversion ring are the best.

Hasselblad softar 1/80-200 zoom @ 135mm/Ekta En/F softar 1 + 81B/exp f.11

B/W filters

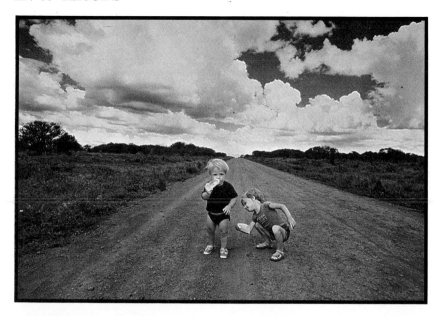

Black & White
Filters are used
with black and
white film to gain
greater separation
between tones of
grey. A filter will
lighten the tone of
colours in its own
end of the spectrum
and darken those
at the other end.
The most relevant
filters for black and
white photography
of children are red,
orange and
graduated.

**The road to
Nairobi.** The red
filter has made the
blue sky almost
black, emphasising
the clouds. The
green foliage is also
nearly black and
the skin tones have
lightened.
*F red/24mm/HP5
dev Microphen exp
auto +²/₃/straight
print grade 3*

The orange filter
has held the tone of
the blue sky and
increased the
contrast of the
whole picture.
Orange filters hold
the tone that the
eye sees and red
filters exaggerate
the contrast – they
do the job that
polarizers do for
colour film. Be

careful to give
plenty of exposure
when filtering
black and white
otherwise you get
no shadow detail
(+¹/₃ for orange,
+²/₃ for red).
*F orange/HP5 dev
Microphen exp auto
+¹/₃/80-200 zoom
@ 105mm/straight
print on grade 3*

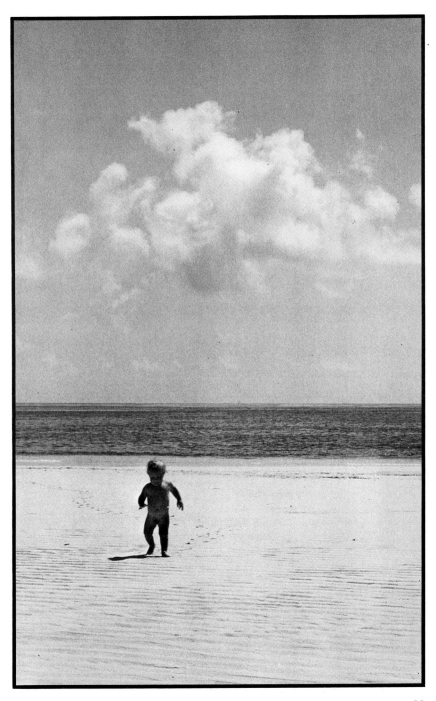

Natural light

The ability really to 'see' light, to interpret how the prevailing light conditions will transpose on to a particular film, is the most important technical skill required by a photographer.

Light is the magical ingredient that makes a good picture into a great one. In fact photography has been described as the 'architecture of light'. Constantly train yourself to 'read' light, not just whether it looks nice, but how it will photograph. There are, however, very few impossible light conditions for photography if you can 'read' the light well and expose and filter effectively for it. Many of my favourite pictures in this book were taken in less than ideal conditions – children don't always wait for perfect light to do their thing.

Matthew rather fancied himself in my T-shirt and sunglasses. The sun was setting over Lake Powell, USA, and the light has a warm glow about it. Look out for both alternatives around sunset – the silhouettes against the sun and the warm light falling on your subjects. Children enjoy posing when *they* consider they look good. *24mm/Ekta ER/F A2/exp auto*

In Barbados it rained each day at 3.00 p.m. on the dot. This day the sun burst through the clouds at 2.56½ p.m. (approx) and silhouetted father and child against a silver sea – I just had to take the picture. *80-200 zoom @ 120mm/Ekta EPR/ exp auto*

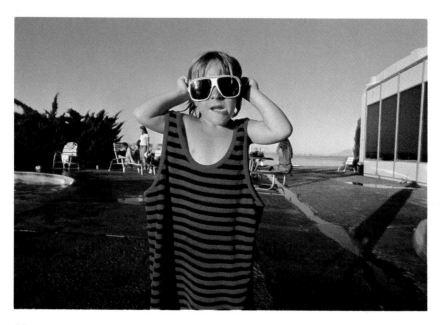

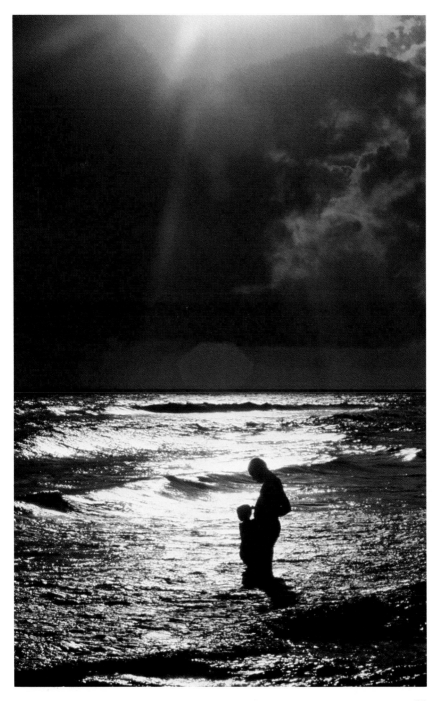

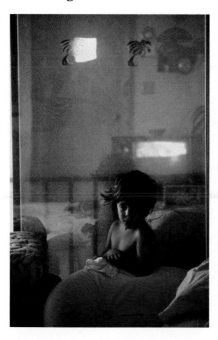 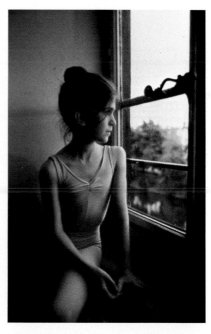

We were on holiday in Florida and Matthew was ill and feeling sorry for himself. He is about three metres from the window. I have exposed for the highlights, leaving the shadows dark and moody. The background is a mirror reflecting the room.
28mm/F 81ᴬ/Ekta EL/exp f.2 @ 125th

Window Light
(Above right)
The last of the sun was glowing through the window when Françoise arrived home (in Strasbourg) from ballet lessons. I sat her down at the window straight away. Her thoughts were still far away (dancing Swan Lake perhaps). She has natural poise, so I didn't interfere – I did my job and she did hers. You must take exposure readings close-up off the face to be sure when shooting by window light.
35-105 zoom @ 35mm/F81ᴬ/Ekta EPR/exp f.5.6 @ 15th/tripod

This shot of our friend Nancy is using the window as a backlight to show off her beautiful profile and, of course, her pregnancy. Michelle found a piece of lace to hang over the window and Nancy added the dried flowers. I used a No. 1 softar, adding to the feminine atmosphere. The colour has been warmed by turning on the room light (a very useful device). I bracketed the exposure (a series of exposures) 1 stop under meter, ½ stop under, one on meter, ½ stop over and 1 stop over.
35-105 zoom @ 40mm/Ekta EL/exp auto −1/F softar 1

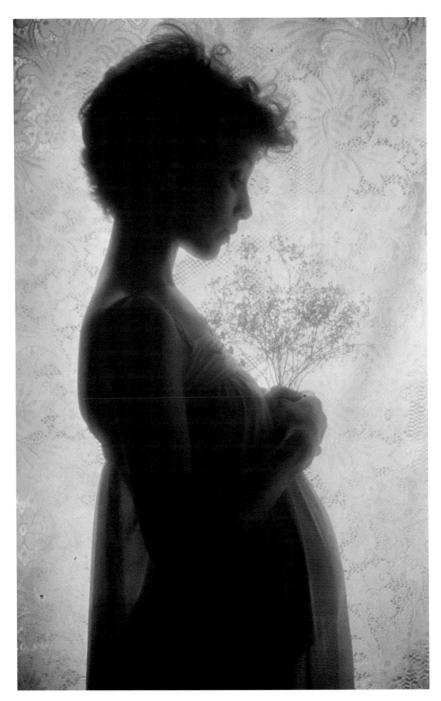

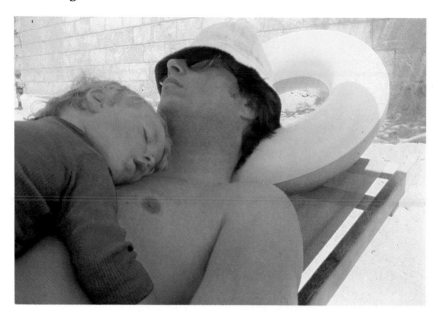

(Above)
Shade light (in this case a beach umbrella) on hard lit sunny days is one of the most flattering of all light sources and sleeping subjects are irresistible.
35-105 zoom @ 40mm/F A2/Ekta EN/exp auto

(Right)
An entirely set-up shot (Kodak calendar). I bought the blue fabric, the yellow pegs and the clothes line. The little girl is the daughter of the cook at my hotel in the Seychelles. The light is hard late morning sun, softened by the

blue cotton foreground. This light can be very effective if you use it flat on like a studio spot light. The tripod was useful to give her a focal point and allow me freedom to entertain – she was very shy.
35mm/Ekta EPR/ exp auto −¹/₃/tripod

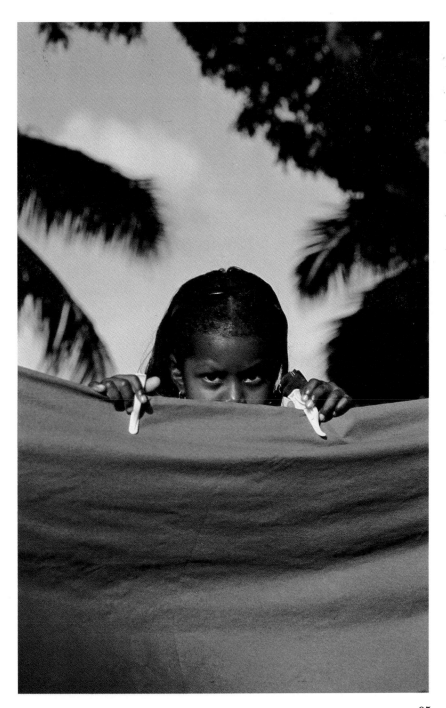

My little friend
Ben Hindle invited us to a concert at his school for children with Down's syndrome. It was a joyous experience – not a dry eye in the house. You need a fast film and a long lens when shooting theatre pictures from the audience. I used Ekta EL exposed at 800 ISO with an 82C conversion filter. *180mm/Ekta EL @ 800 ASA pushed ⅔ in process/F 82C/ exp auto, f2.8 @ 60th/tripod*

I photographed the King's College Choir rehearsal for a magazine assignment. The little lad in the glasses had his mind elsewhere that day. The choirmaster was less pleased with him than I was. Candlelight is magic for photographing children – try it out at home. *135mm/Ekta EL @ 1200 ASA pushed 1½ stops in process/ F 82E/exp auto @ f2/tripod*

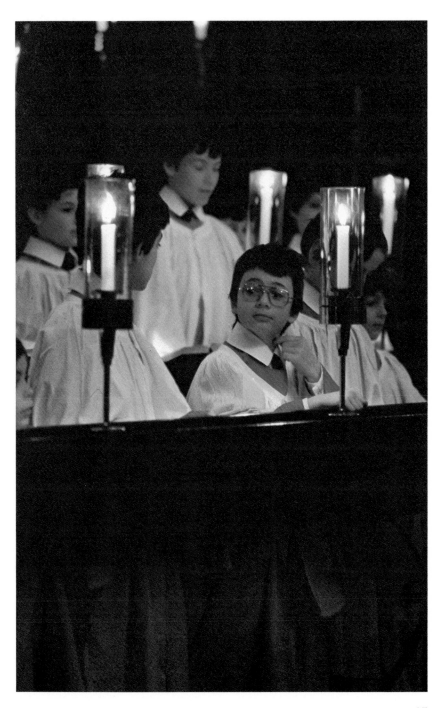

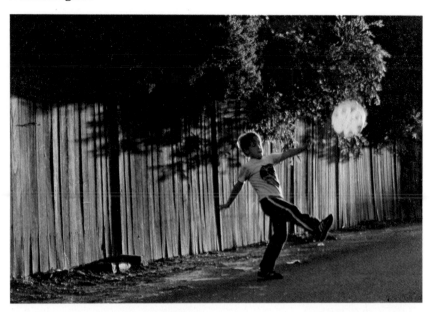

The dilapidated old grey paling fence in the lane near Sydney looked a very unlikely location for a good picture at around 3.00 p.m. But by 6.00 p.m. the late sun had turned the grey to gold and *made* a lovely picture. Matthew was playing soccer against the wall when I arrived, but it was the quality of light that made me pick up the camera.
80-200 zoom @ 100mm/F 81ᴬ/Ekta EL/exp auto

A winter morning in Hyde Park when the angle of the sun is low and has hit the little girl and the goose like a side lit flash gun. The contrast is so high that by exposing for the highlights everything else is reduced to almost black. Tricky light to work in.
80-200 zoom @ 105mm/Ekta ER/F 81ᴬ/exp f.8 @ 250th

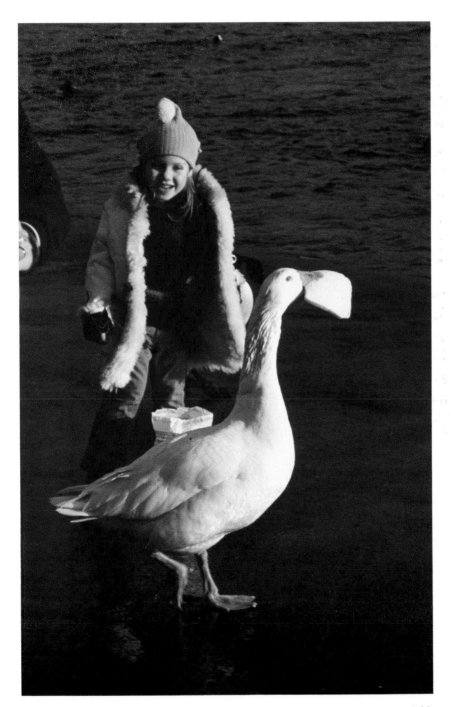

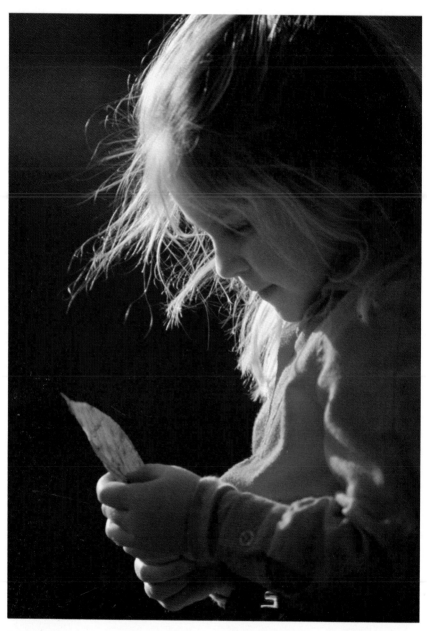

An autumn morning in the park. I stood well off with a 400mm + 1.4 teleconverter (560mm). The ground was covered in leaves. When this little girl picked one up, I moved around till she and the leaf were backlit. You need a dark background for backlight to be effective.
400mm + 1.4 Te./F 81ᴬ/Ekta ER/exp for leaf/tripod

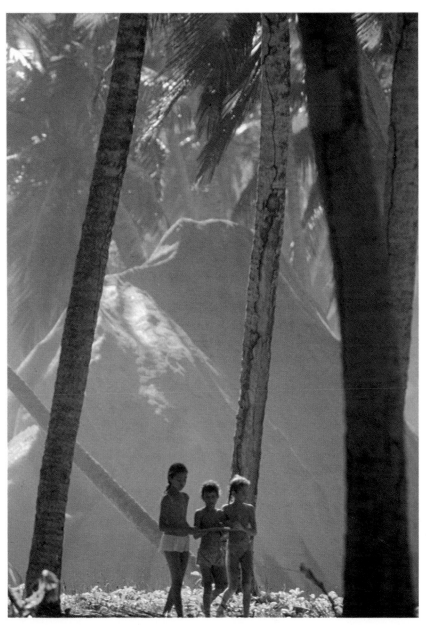

About half an hour after sunrise – the best part of the day, as they say. Similar quality to sundown but cleaner because the dust of the day is not yet in the air. I saw the lighting possibilities first, the children second, and then put the two together.

300mm/F 81ᴬ/Ekta EPR/exp f.4 @ 125th/tripod

This is a lovely family memory. We rushed out of the front door for a few seconds during a snow storm and snapped this picture. Nicholas hasn't even got any shoes on. The red sweater adds punch to the picture. It was all spontaneous. I shot on 30th sec which made the snow streak across the picture.
35-105 zoom @ 80mm/F KR3/Ekta ED/exp auto

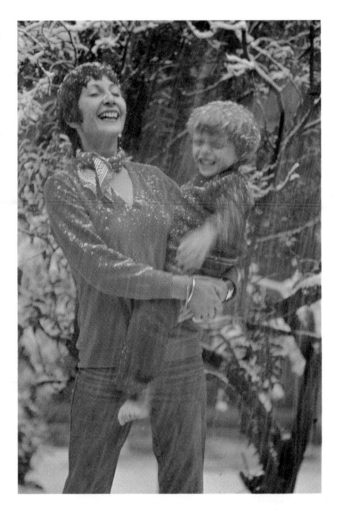

(Top right)
The girl next door. Michelle decorated an old straw hat with fabric flowers. The light was dull – almost raining – but with the help of an 81E filter and the introduction of lots of colour, the picture worked out well. Karen felt good in the hat and acted very naturally. Don't put the camera away in dull weather. The 100 ASA films combined with plenty of warm filtration can produce good soft results.
135mm/F 81E/Ekta EPR/exp auto −1/3 @ f2

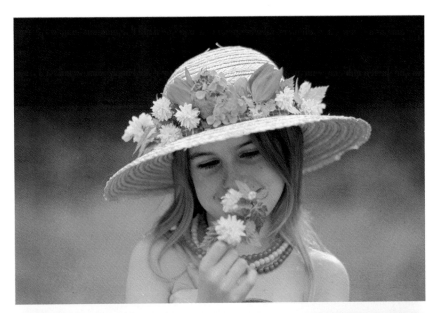

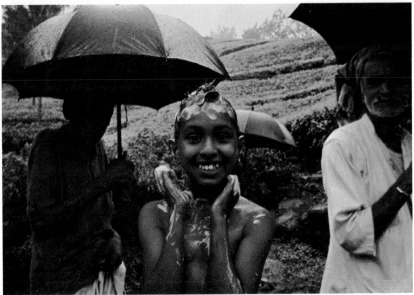

We were driving in monsoon rain through the tea fields of the Sri Lankan highlands. I saw this girl washing in the rain. There was very little light but nevertheless the picture tells a lovely story. Very seldom is the light bad enough to prevent a good picture – if the content is interesting. The little girl's face reflects the friendly charm of the Sri Lankan people.
24mm/F 81ᴬ/Ekta EL/exp auto

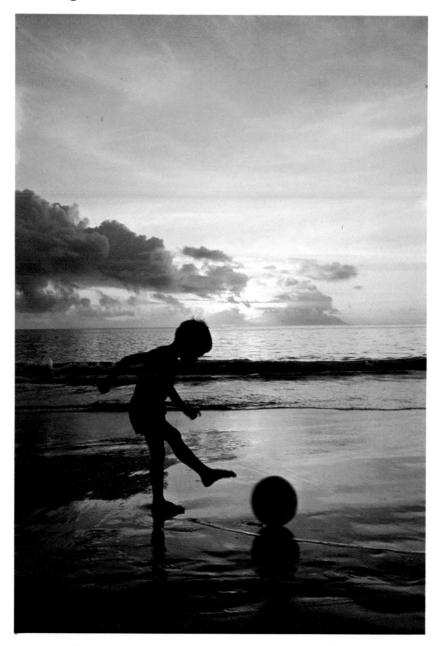

The boys had been playing football on the beach for hours. It wasn't difficult to persuade them to play once more for the camera, in front of the sunset this time. It's almost criminal on holiday not to have a loaded camera handy at sunset. *80-200mm lens/F A2/Ekta EPD/exp auto*

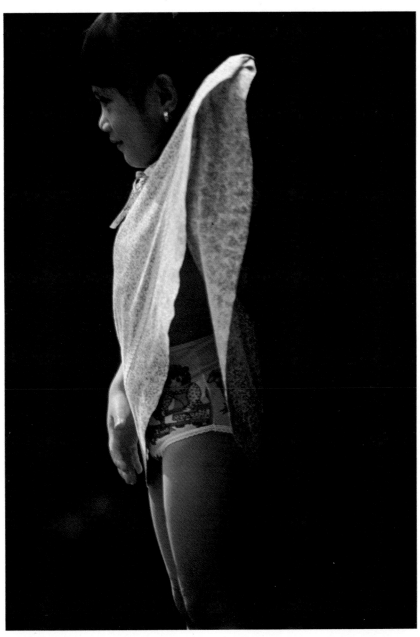

I stood Marianne in the only shaft of light that penetrated the garden shrubbery. Apart from that this picture was not directed. The light has emphasised the strong graphic shape made by Marianne's dress.

80-200 zoom @ 135mm/Ekta ED/F A2/exp auto −1/3

Natural light – black and white

Good content is the most important consideration in black and white photography – you have no pretty colours to help you out, so it is vital that you learn to evaluate light and colour into tones of grey and to assess their effects on black and white film.

Use your TV set as a guide: by twiddling the colour control knob from colour to black and white you can see how the colours convert into grey tones.

But the bottom line is 'if it looks good, shoot it'. You do have the opportunity to make adjustments later in the darkroom.

Nicholas and friend met on a winter's walk in Hyde Park. The crisp morning backlight looks well in black and white – the colours have been converted into strong shapes and the picture has a dramatic tonal range.

35-105 zoom @ 75mm/HP5 dev Microphen exp auto + ⅓/printed on gr.3, shading back the two figures

The beach was in shadow except for the patches of late afternoon light that pierced the trees of the foreshore. I followed the little boy's walk down the beach through the camera; when his bottom walked through a shaft of light the shutter went off almost by itself. You have to be prepared – light changes terribly quickly.
80-200 zoom @ 200mm/HP5 dev D76/exp auto/print on gr.3, sea shaded slightly

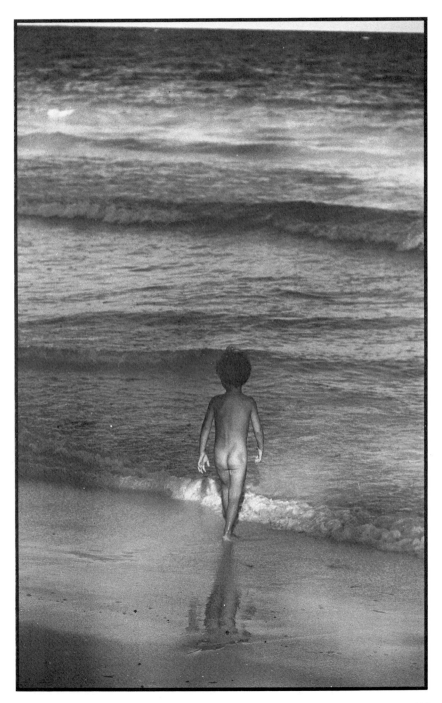

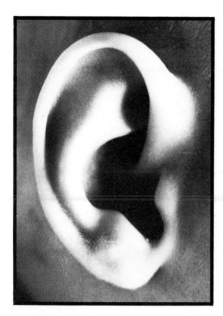

The picture of Nick's ear (taken while asleep) relies almost entirely on the modelling provided by the window light. It is an exercise in light and shade.
35–105 zoom (macrofacility)/HP5 dev/Microphen exp auto/tripod/print gr.4, shaded ear lobe

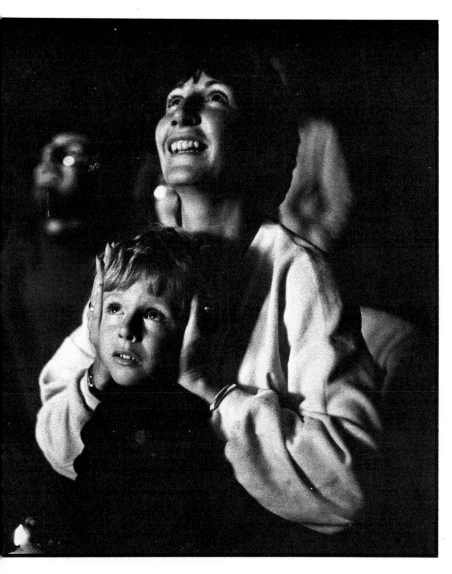

Our community
fireworks display
on Guy Fawkes'
Night. Nicholas
loved the spectacle,
but not the loud
bangs. The light is
only that of the
bonfire. Look at the
available light
carefully before
you pull out the
flash gun. Flash
would have killed
the glow of
Michelle's and
Nick's faces.
*50mm/HP5 dev
Microphen/exp auto
60th @ f.1.4/print
gr.3 straight*

Flash

Most low light situations can be photographed by the combination of fast film, large aperture lenses and a tripod.

Flash can be used as another different, but potentially creative light source, not just as the last resort. The problem of achieving consistently correct exposures on transparency film has been largely solved by the recent development of two flash systems. The TTL (through the lens) system and the computer sensor system – some units incorporate both.

The TTL system meters the light actually reaching the film. You can set the camera on any stop (useful for depth of field control), and the unit will produce the right amount of flash for a correct exposure.

The computer flash monitors the amount of light illuminating the subject. You set the f stop required (choice of three or four) on the computer dial and the corresponding f stop on the lens.

The major camera manufacturers produce what is called dedicated TTL flash units, which work only with the TTL flash metering system on their own cameras. The independent manufacturers like Vivitar produce flashes with modules to fit any camera system.

Remember these small flash units only work up to ten metres from the subject at the most!

I first made an exposure reading of the sky and trees. The camera meter said f.8 @ 60th second. I set the camera @ 250th at f.8 (the Nikon FE2 synchronizes at up to 250th second), and the computer flash at f.8. I was therefore underexposing the background by 2 stops. The result is that Matthew appears almost as a 'cut out' against the background. The flash has really zinged out the colours. *35-105 zoom/ computer flash/Fuji 400D/F 81B over flash/exp 250th synchronized @ f.8*

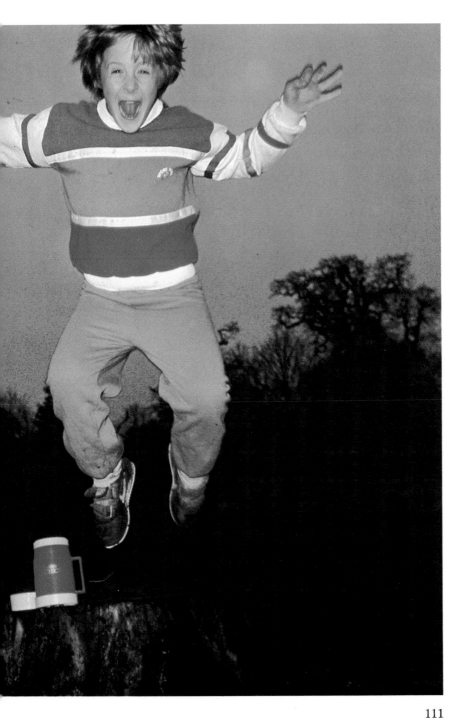

This is a series of portraits of Blanard using just one small flash head with tissue paper over the front to soften the light.
1 Flash on the camera, flat, and hard.

2 Flash held at arm's length (on extension cable) above the camera. There is more moulding in the face now.

5 Flash in same position as No. 4. Blanard has turned profile to the camera to face flash.

6 Flash from near the floor produced a ghostly appearance.

3 Flash on a stand 45° between Blanard and the camera – a classical portrait light.

4 Flash side lit.

7 Flash hidden behind Blanard and bounced off the grey background.

8 Flash behind Blanard pointing at the back of her head. I held a white card in front of her face (just out of frame) bouncing the light back into her face.

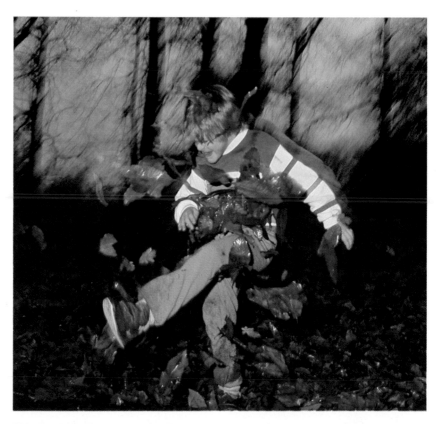

This shot is similar in technique to the opening picture – two stops underexposed on the background. But this time I have synchronized the flash on a 30th second and panned the camera with Matthew as he moves. The 30th second has blurred the background and the flash has frozen the 'kick'. The technique adds to the feeling of movement.
30-105 zoom @ 65mm/Fuji 100D/F 81ᴮ over flash/exp 30th @ f.11

Nathan Korda lives almost next door. He was seven months old when I took this picture. His mum sat him on her knee and supported him around the waist while keeping herself out of the frame. This is the safest and most comfortable way to take portraits of babies of his age. I used one computer flash (diffused by tracing paper) at about 45° between the camera and Nathan, plus a white reflector one metre from him on the other side to 'fill' the shadows. The background is a blue bath towel, the blue to match his eyes and shirt. The session was set for 2.00 p.m. when his mother suggested he is usually in good form. Remember with babies you have to fit into their schedule, not the other way around.
80-200 zoom @ 150mm/F A2 + no. 1 softar/exp @ f.8

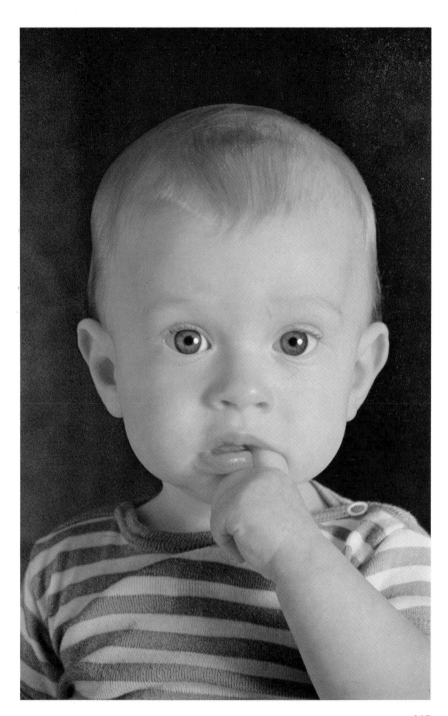

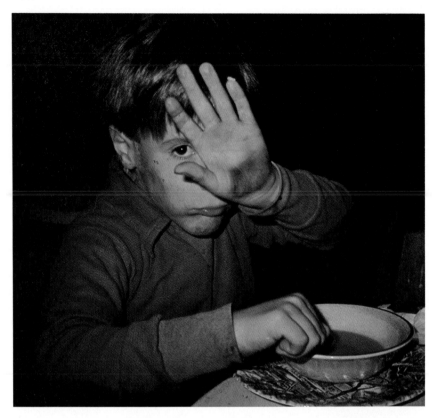

(Above)
Flash on the
camera. Matthew's
expression says it
all for me. I avoid
flash on the camera
as much as possible
when shooting
colour. It's a harsh,
unsympathetic
light source.
*35mm/Ekta EN/
flash on camera/exp
auto*

(Right)
Flash on the
camera works fine
on black and white,
however. I took this
picture at the
Mickey Mouse
Club's birthday
party. Matthew
had just collected
his present when
the big bad wolf
appeared from
nowhere. This is a

reflex shot from my
seat in the
audience. The flash
has captured the
sinister looking
action (Matthew
was not eaten) very
cleanly.
*35-105 zoom @
105mm/HP5 dev
ID11/exp auto on
TTL flash/print,
gr.3. Matthew's face
printed in*

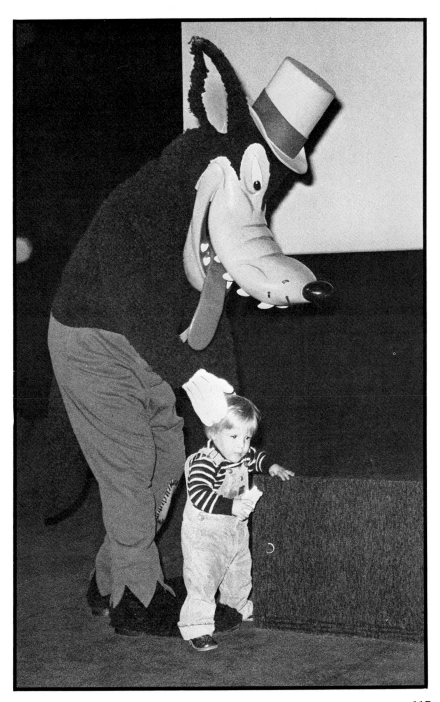

Studio

The use of a studio is the only opportunity we have to make a visual record of a child with no background distractions – to express the child's personality and mannerisms honestly.

For some strange reason many photographers start talking baby-talk and behave childishly in an effort to communicate with the baby or child as soon as the poor victim enters the studio. Children are not Martians – only small people. They are relying on you to give them confidence and reassurance. Another three-year-old behind the camera, they don't need. Be firm, polite and precise: confident, relaxed and *unhurried*.

Children have a shorter concentration span than adults (well, most adults), so it is essential to be absolutely ready before you start shooting – meter readings taken, camera loaded and next film ready. You can set up lights using an available adult as stand-in. With older children (five plus) I often have them help me set up the studio – they enjoy feeling part of the whole thing.

When photographing babies the studio (which is probably the sitting room also) must be *really* warm and cosy. If the child is not yours, I think

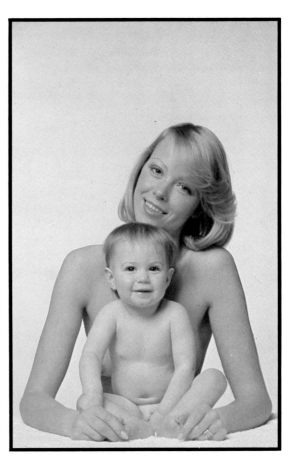

it's better to have the parents out of the room, so that you can work on your relationship together, without reference to a 'higher power'.
Lighting should be kept simple. If I can't use daylight, I try to reproduce natural lighting situations that I've observed. Flash is useful for children under three because it 'freezes' their movement.

Finally, if the child or baby is not in the mood, forget it and try again tomorrow – it shouldn't be made into a big deal. If you try to 'battle on' both you and the child will get unnecessarily tense, and the next session will be twice as difficult.

An assignment for *Parents* (France). The mother and baby lay on a mattress on the floor and I shot directly over the top of them.

The studio was heated.

What you don't see in this rather idyllic picture is the scene earlier when this charming little chap peed all over the horrified model.
35-105 zoom @ 90mm/Ekta EN 100/F 81^C + No. 1 softar/exp f11 with studio flash

This glossy image was required for a magazine cover. I set up with a table covered by a warm fluffy white towel.

The composition is contrived within the outline of the mother's arms, the baby feeling comfortable on the towels and leaning against her mum. Mum made baby smile by tickling her toes.
80-200 zoom @ 120mm/F A2/Kodak 64/exp f8 with studio flash

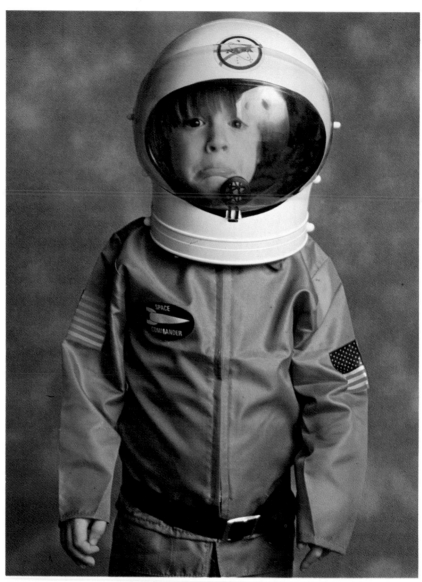

The astronaut suit was Matthew's birthday present. I sprayed a grey background roll with a white spray for the cloudy effect. The light comes from a single studio flash head bounced into an umbrella.

I started the session without the umbrella's reflection in the visor and only noticed it by accident. I decided that it added a spacy feel to the shot. Concentration is the most important requirement for a photographer. Expressions are such fleeting moments, you don't want to miss *the* one. Played David Bowie's Major Tom record during the shoot.

80-200 zoom @ 120mm/Ekta EPR/F 81^A/exp f.5.6

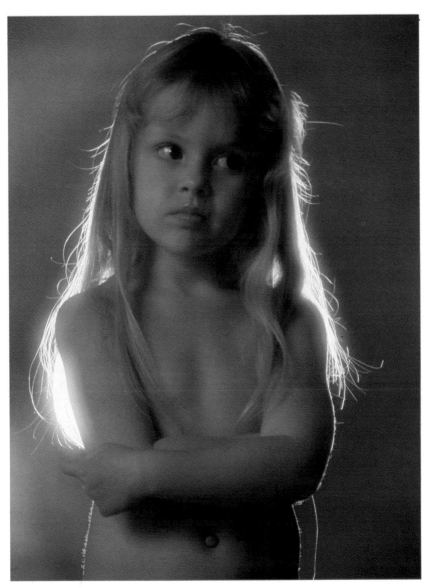

This is another idealised image for a magazine assignment. The little lady (a model) is very beautiful in a 'Pears soap' kind of way.

The main light is coming from two floods diffused through tissue paper. The lights have blue filters to balance them for daylight film. The backlight is from a single flood through a hole in the brown Colorama, giving her that angelic glow.

The camera angle is waist level, looking slightly up at her. She was rather grown up, so we talked of rather grown-up things and played Mozart!

80-200 zoom @ 100mm/Ekta EN 100/F 81E + no. 1 softar/exp f.4 @ 60th second

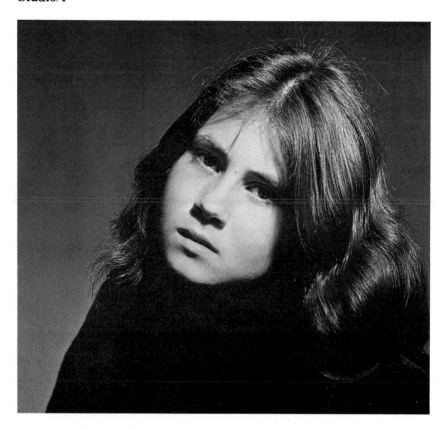

A portrait for Lerryn's father. I asked her to wear a plain black polo neck sweater so that nothing would distract from her very pretty face. The light is from a single spot – strong for a child, but Lerryn was at that transitional stage between childhood and womanhood and it suited her well.

For portraits keep the clothes plain and simple, no busy patterns. *80-200 zoom @ 180mm/FP4 dev D76/exp 60th @ f.5.6/print gr.4 eyes shaded, flash exposure during dev*

A cover for *Parents* magazine in Paris. These sessions are always well organised with six babies and several assistants. This shot works because we built up the floor one metre off the ground to enable me to get a low angle on our cover boy – one is used to pictures that look down or straight on at babies.

It's sensible to use a large clean light source when a baby is alone and very mobile. He will then be well lit, no matter where he moves. You need two helpers to act as catchers just in case!

The timing of baby pictures is crucial and you must be advised by the mother – I find that after a sleep and a little feed is usually best. There is no point in persevering with baby if baby is not in good form. *80-200 zoom @ 100mm/Koda 64/F A2/exp f.11 with studio flash*

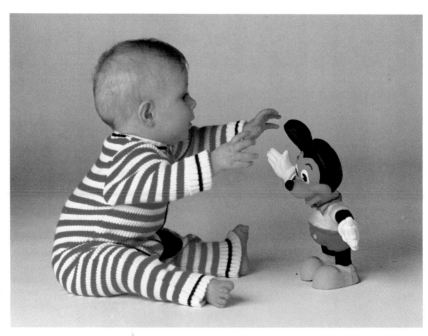

This series of pictures is an exercise in colour co-ordination. Michelle bought the jump suit and the trumpet with a picture in mind. Nicholas was interested in the trumpet (he hadn't seen it previously) so the pictures were easy. We popped Mickey Mouse in near the end – just because he was one of Nick's favourite toys and I shot just as he reached out for him.
80-200 zoom @ 85mm/F KR3/Ekta EPR/exp f.11 with studio flash

One of our favourite portraits of Nicholas – made very quickly, when he was two-and-half. I set up with flash well before he arrived. He had just woken up, his hair was still tousled and he hadn't finished dressing. He looks both intense and vulnerable – don't scrub and brush all the personality off the children before you take the picture.
Hasselblad 150mm/Ilford FP4 dev ID 11/exp f.11 with studio print gr.4 straight with flash exp during development

I had a grey background already set up when Matt came in from school and a few frames left in the camera. I asked him to sit on the stool for a couple of snaps, he plonked himself down half-way through changing out of his school uniform.

This portrait really captures a side of Matthew's personality and is typical of the 'Just William' type of little boy. The spontaneity of the moment was the key.
85mm/HP5/exp 125th @ f.5.6/ tripod/print gr.3 straight

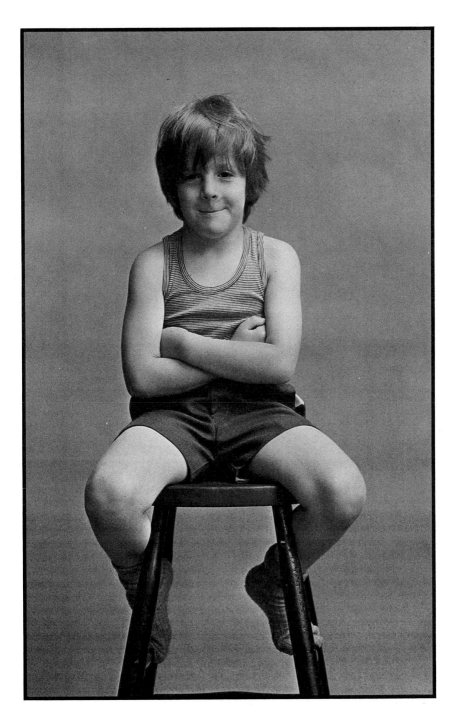

Framing and composition

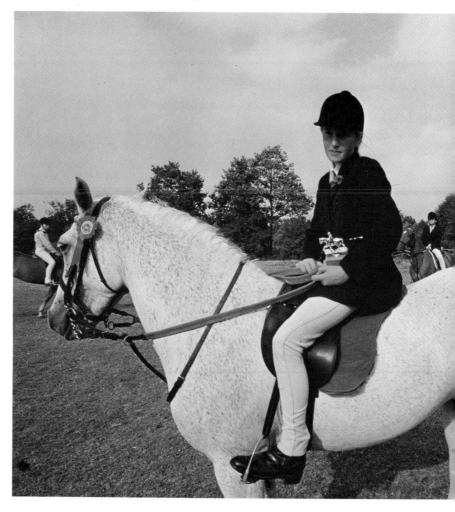

There have been many learned books written on the theory and formulas for composition and design, but I feel that most framing and compositional decisions in photography should be dictated by the need to tell a story in the most effective way possible.

The first big step to take towards making strong compositions is to start to see the subject and the surroundings as just shapes and colours (or tones in black and white), and to be conscious that the shapes between and surrounding the main subject or subjects (the negative shapes) are as important as the shape of the main subject itself (the positive shapes).

Modern viewfinders have a major compositional trap that we must fight against. The fine focus circle and the centre weighted metering seduces you into plopping the child in the middle of the frame and pushing the button and producing stacks of well exposed, boringly composed pictures.

The late afternoon sun on wall and trees looked interesting but not enough for a good picture. Matthew obligingly ran through the gap that I left for him and 'made' the picture.
35-105 zoom @ 85mm/Fuji 100D/ FA2/exp auto −1/3

I was looking for a harmonious, balanced composition here. The horses were all moving around, I pushed the button when they all came together in a symmetrical pattern.

All good photographers instinctively feel when they *have* to take the picture.

The great French photographer Henri Cartier-Bresson called it 'the decisive moment'.

A 28mm lens has slightly exaggerated the perspective, adding strength to the composition.
28mm/Fuji 100D/ FA2/exp auto

131

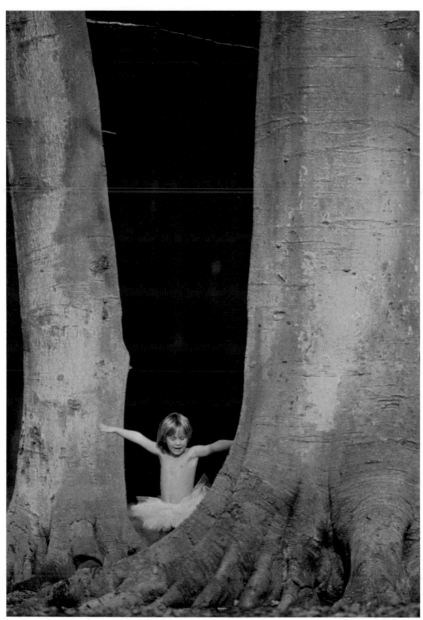

The great tree emphasizes the petite femininity of little Katie Ridley. The strong V-shape speeds the eye down from the top of the frame and locks it in at the bottom. I must confess to spinning Katie a tale about a fairy that lives at the bottom of that tree – well, it may even be true. Anyway, she looked around long enough for me to take three rolls.
400mm/Ekta EPD/ F81A + 5A gels/exp 250th @ f.3.5/ tripod

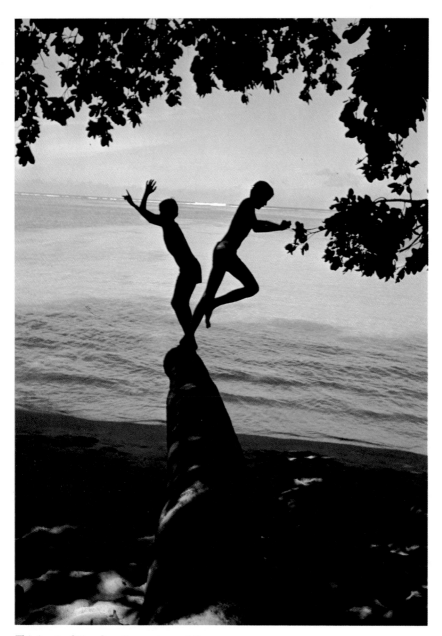

This is a traditional framing device. The tree and the black foreground shadow area force the eye toward the figures of the boys. *Nikonos IV 35mm lens/Ekta EPR/exp auto*

133

The 300mm lens was on the camera lying next to me on the car seat when I was in Kenya. I spotted this little guy running across the sunlit wall. I stopped the car, framed up the picture very fast and waited till he was just about to break out of the frame within the frame before I took the shot.
300mm/Ekta ER/ F81ᴬ/exp auto −¹/₃

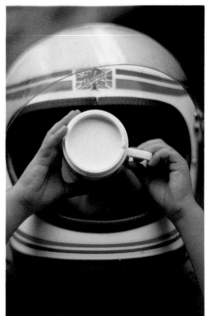

Another frame within a frame. This shot of Matthew would lack impact if the framing had not been so tight. The picture is a design using round shapes.
80-200 zoom @ 120mm/Ekta EN/ FA2/exp auto

Framing black and white

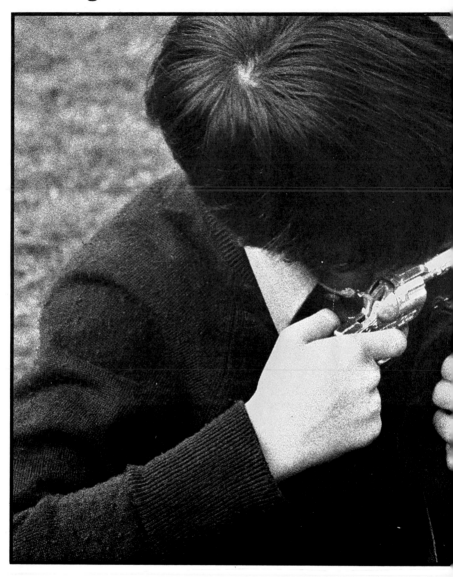

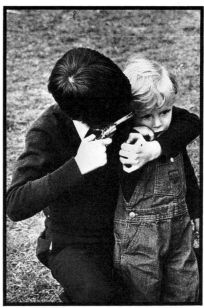

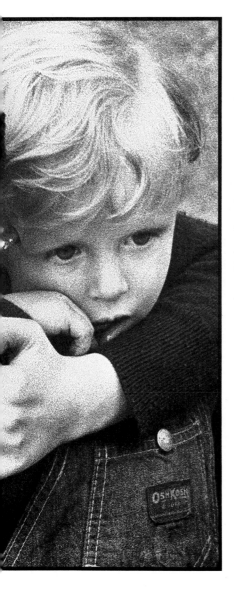

I shot this picture in its original composition (right) on a Sunday walk with Nicholas (18 months old).

A group of 12-year-olds were playing cowboys or cops and robbers or something. I turned around to see one of the boys holding a gun to the head of a rather confused Nicholas. I took the picture instinctively. It was first published in its original composition (as shot in camera) in a book called *Family of Children*.

The picture was then used by *Stern* magazine to illustrate an article on children and violence. The art director looked at the picture with a fresh eye and cropped it tight to produce a dramatic double page spread (*left*). The art director's composition is more dynamic than mine. Nick's face is almost crushed against the edge of the frame, there is no space around him – nowhere left for him to escape to. The picture was then used in this composition by *Oggi* (Italy) *Parents* (France) and *Look* (USA).
105mm/HP5 DEU Microphen/FLXP auto
Print (original) straight gr.3 (revised) gr.3 hands printed in

Colour

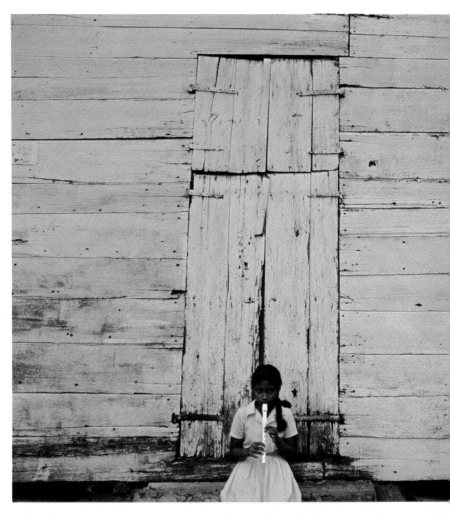

Colour is not just ornamental. Different colours and combinations of colour produce different emotional responses.

You know that warm colours (reds, orange, yellows) receive a warm response and cold colours (blue, green) a cooler response but it's important to be aware that you can largely control the colours and therefore the emotional impact of your pictures. The film and filtration choice and the quality of light, plus the choice of clothes the children wear, combine to give you a chance to determine the whole mood and feel of your picture.

I must add that all this attention, care and planning can be completely wasted if you don't take equal care in choosing a conscientious colour laboratory. You owe yourself that.

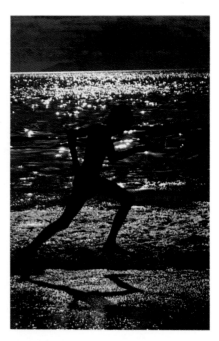

I was attracted to this picture because it was devoid of almost any colour. I exposed for the extreme highlights of the sea, which removed any colours from the silhouetted runner and his red swimming trunks. Exposure has a great influence on colour.
80-200 zoom @ 150mm/Ekta EN/exp auto −1

The green wall could be seen from the playground of the school where I was taking pictures. The yellow of the uniform and the aged green of the wall were irresistible. I made my musician (it was the middle of the music lesson) small in the frame – I wanted just a 'drop' of yellow.
24mm/F81^C/Ekta EPR/exp auto −1/3

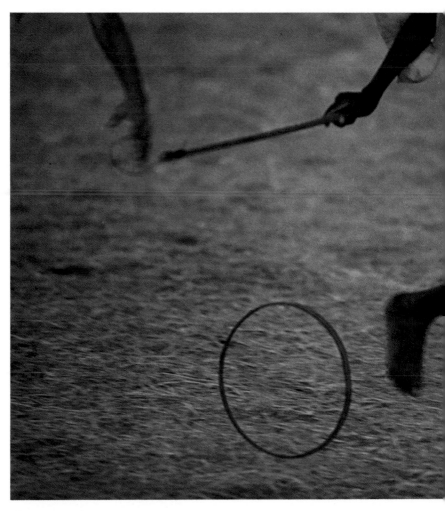

This picture relies only on colour and composition for its effect. The sepia colour gives a warm feeling to an otherwise abstracted form. The colour is due to strong 81EF filtration.

180mm/Ekta ED/F
81EF/exp auto

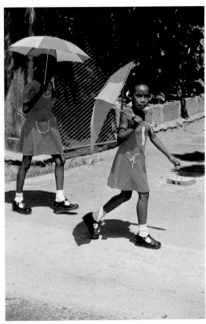

You certainly couldn't miss this burst of colour going by – nothing subtle or clever about it, but gay and cheerful nevertheless.
35-105 zoom @ 40mm/Ekta EN/F A2/exp auto

Setting up on location

Matt received a pair of bright red boxing gloves for his birthday. I decided to set up a picture of him in a boxing ring as a possible page in the Kodak calendar that I was working on at the time.

I was able to use the boxing ring in a London youth club. Matthew was dead keen on the idea.

We shot several versions of the boxer – some with his pal Parker. We covered him first in baby oil to get a sweaty shiny effect and then added some make-up for the black eye and bruises. I lit the picture with one studio flash reflected into a gold umbrella (for brown skin and to zing out the reds) high over my head.

His two trainers giving him a desperate pep talk before the last round were my agent and the boxing coach from the club. We all had a great time. Matthew surprised me with his acting ability. I think he really 'lived it' because of the great atmosphere in the gym.

Kodak didn't use the picture because they thought it looked too real. *85mm/Koda 64/F 81ᴬ/exp f.8 with flash*

Georgina was on holiday from Australia and staying with friends. She jumped over the wall one day to play with the boys. I had been planning a picture of a little girl dressing up in her mother's old clothes, for the Kodak calendar, and here she was, just perfect.

Michelle set up the picture in a neighbour's house. We used Michelle's clothes. The existing daylight was too low and too blue. I added a flood light (diffused by tracing paper). The unfiltered tungsten lamp has warmed up the daylight, making the scene more lush.

Georgina really got into the act and was a right little madam. Try setting up some situations for yourself – taking your lights and props (and model of course) to a location. Most children respond well to a good atmosphere and really enjoy themselves. You must think the situation out thoroughly and know exactly what you want to do, otherwise the child will feel insecure and unable to perform.

35mm/Ekta ED/exp f.5.6 @ 60th second

Motor drive

There are times when a sequence of pictures of an event is more effective than a single image. The motor and auto winds have made this a simple task.

Matthew returned home from a party with this rather large balloon. He was aware that I was shooting this sequence of pictures but was too involved to pose. I shot from ground level to illustrate how high he was jumping. The ability to follow focus is essential for this type of shot. I've been asked to point out that Matt's wearing a Tottenham Hotspur shirt. *35-105 zoom/Ekta EL/F 81ᴬ/exp auto*

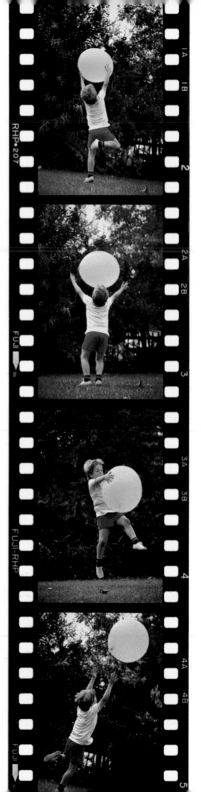

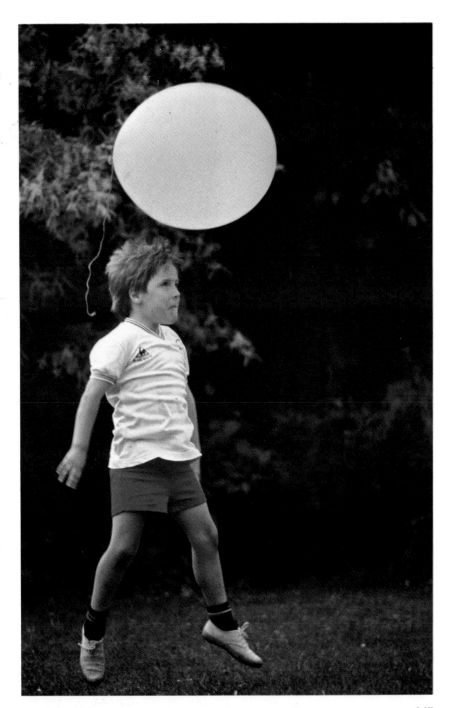

Motor drive/2

The divine pastries of Salzburg were an irresistible temptation for Matthew. I was sitting opposite him at the table and let the motor drive run as he moved in for the first assault. The 28mm lens has slightly elongated the face and mouth and exaggerated the size of the pastry, adding to the humour of the sequence. It is almost a photographic caricature.
28mm/Ekta ED/F KR3/exp auto +⅓

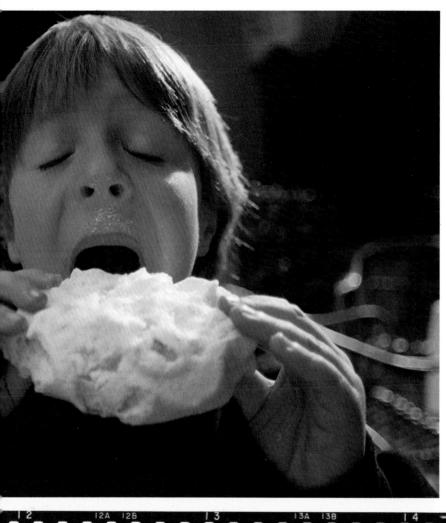

Reportage

This section is devoted to pictures taken of children unobserved – a peep into the world of the child.

Matthew, Joanna and Gloria acting out a game with the Pink Panther. The sort of picture you get only by keeping a camera around your neck on holidays.
35-105 zoom @ 35mm/Ekta ED/F A2/exp auto

I had observed this little boy arguing with his father (in Greek) on the jetty fifteen minutes earlier. When I passed by a second time, the reason for the argument was obvious – he wasn't allowed to go fishing. He sat there for ages, poor chap.
80-200 zoom @ 150mm/Ekta ER/exp auto

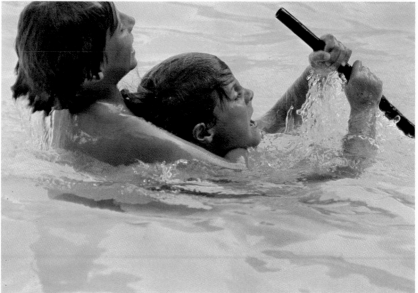

Nicholas and Matthew fighting for the snorkel. I can't remember who won! The fast shutter speed has 'frozen' the water. *80-200 zoom @ 180mm/Ekta EN/F A2/exp auto*

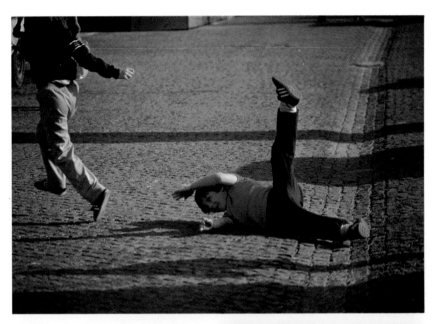

I didn't disturb the intense concentration of Nicholas and Nicky. I cropped in tight to emphasize the protective circle they form around Action Man.
80-200 zoom @ 200mm/Fuji 100D/F KR3/exp auto

After a tussle Matthew crashed down rather more elegantly than usual – Nick wisely made a quick get away. I shot a quick burst on the motor drive.
35-105 zoom @ 105mm/Ekta EL/F KR3/exp auto −1/3

When I saw Spiderman go out into the garden I followed. I shot several pics with a 300mm lens while he paused to consider which of our walls he should climb. The out-of-focus foreground bushes (I was hiding behind) add to the secrecy of the affair.
300mm/Ekta EL/exp auto

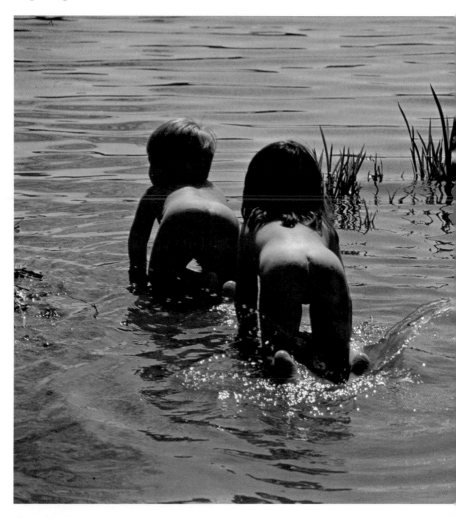

These two (I've sworn not to name names) were playing follow the leader for ages. I shot two rolls, but the composition and light have come together here to make a sweet picture. They were too busy to notice me.
80-200 zoom @ 150mm/Ekta EPR/F 81ᴬ/exp auto −1/3

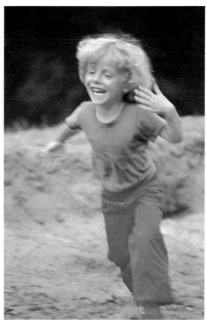

I shot a roll of Nick rushing about. The shutter speed of 60th second wasn't fast enough to 'freeze' the action – the blur adds to the excitement, however. You must be prepared to shoot lots of pictures in reportage situations – you have to go with the flow.
35-105 zoom @ 40mm/Ekta ED/F A2/exp auto

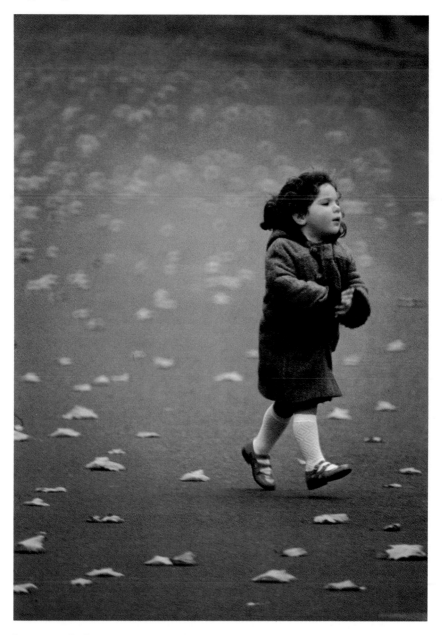

I was set up in the middle of the Mall to photograph the Horse Guards when I spotted this little lady striding across the road and turned the camera to take just one frame. I was on a 500mm in anticipation of the Guards procession. The composition gives the impression that she is about to stride out of the picture. *500mm/Ekta ED/exp auto*

I took this picture of the sack race winner at a school's track meeting in the Seychelles. You need both eyes open to watch all the lanes for the probable winner. The further away you are with the longest lens possible is the easiest way. I pre-focused on the winning tape. I used a motor drive. *Specs 400mm + 1.4 tele-converter/Ekta ED/F 81B/exp auto*

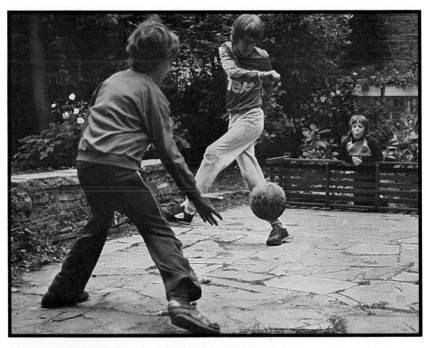

Oliver and Nicky Bishop playing football with Matt looking on. When children are in action they are oblivious to photographers. *35-105 zoom @ 45mm/HP5 dev ID 11/exp auto/print gr.3 edges printed in*

The end of a hot day at the beach in Malindi (Kenya). I printed for silhouette, no detail was necessary. *35–105 zoom @ 35mm/HP dev ID 11/exp auto/print gr.4 printed dark for silhouette*

I shot this rather risqué picture in Hyde Park – just a moment frozen out of a hot summer's day. *80-200 zoom @ 105mm/HP5 dev Microphen/exp auto/print gr.3 straight*

The little girl and her dog drinking is just an observation I made on a Sunday morning stroll in Hyde Park. I often carry a camera with one lens (usually 35–105 zoom) and a couple of films in my pocket.

35-105 zoom @
105mm/HP5 dev
Microphen/exp

auto/ print gr.3
shaded in top edge
of frame

Photo story

The most important thing to remember when shooting a photo story of an event is that you must plan ahead. You have to be in the right place at the right time with the right information and . . . the right permission. You can't chase the action, you must be there first and wait for the action to come to you.

Let the organizers know what you are doing so they don't get any nasty shocks when you suddenly pop up to take a shot. What you require most is co-operation, so tread carefully and don't create bad 'vibes'!

The Gymkhhana photo story was an assignment for the *Sunday Express Magazine* as part of their issue on the horse-crazy British. Each picture is a personal observation and, taking the photo-journalists' adage of 'one picture is worth a thousand words', I will say no more.

This photo story of the Vale School (Chelsea, London) sports day was shot purely as a family memory – both Nicholas and Matthew were students there. It turns out to be also a documentary on a part of the English way of life, of course.

A mini photo story from one of Matt's birthday parties. We engaged an entertainer for the afternoon – as you can see he went down big!

Photo story/6

I was fortunate enough to spend a day back at school with the teachers and students of the Vale school. At first the children were totally distracted by my presence, but it was extraordinary how quickly they became bored by me and got back to work – I became almost invisible.

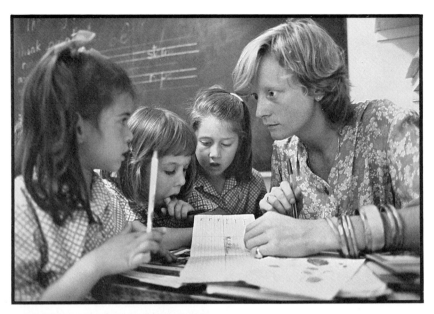

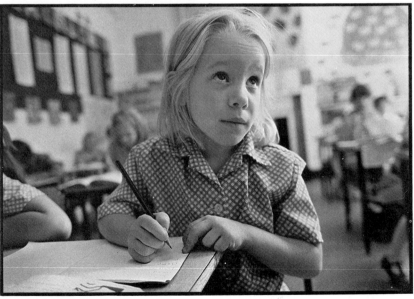

Memories

We were staying in a beach house in Malindi, Kenya. Samadi was the daughter of our cook. She and Matthew were both three years old at the time. We decided to photograph the two of them together – the pictures were bound to be charming whatever they did. Michelle gave Matthew the red ball to introduce a drop of colour, he passed it on the Samadi and then provided his own drop, or rather stream of magic! I was changing films when Michelle yelled out to me. I spun around getting off these reflex shots. This one on the left is the best. The combination of a motor drive and a zoom lens made it possible. Plus the bit of luck that often follows good planning.
80–200 zoom @ 150mm/Ekta ER/F 81ᴬ/exp auto

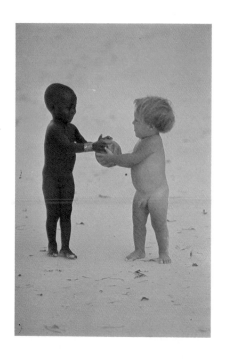

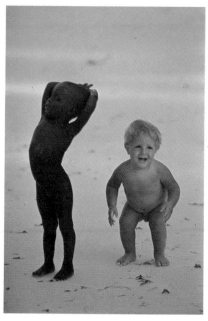

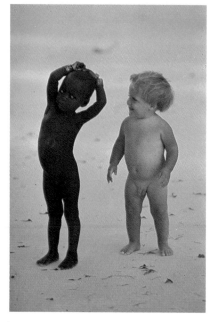

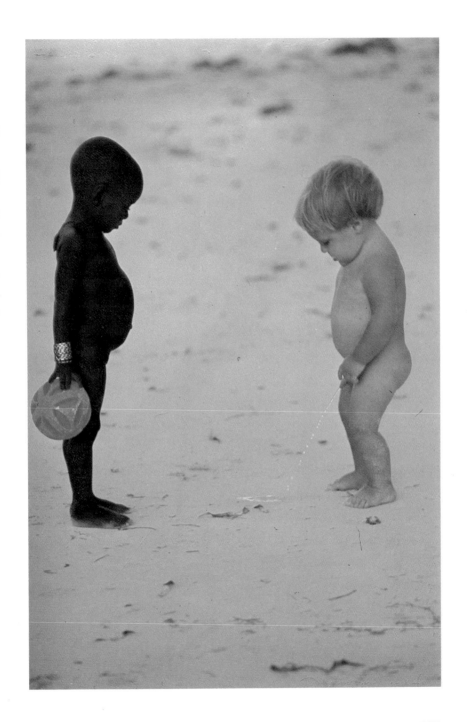

The cat that swallowed the cream – Nick loved the little car merry-go-round in Brighton. This snapshot says it all. Practise till you can follow focus almost automatically – it's an absolutely essential skill.
80-200 zoom/Ekta ER/F A2/exp auto

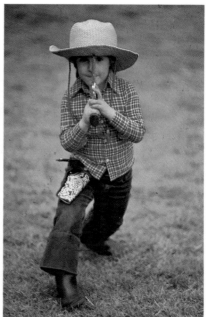

All parents of boys remember this stage. Matthew used to be six different characters every day – this was his Cisco Kid number. Keep the backgrounds clean and simple. *85mm/Fuji 100D/F A2/exp auto*

This was Matthew's first day at the Vale school. He was not entirely happy about wearing a cap. The weather was very dull. I shot with KR6 filter to hold the colour of the cherry uniform. He went on to lose five caps in five years. *135mm/Ekta EL/F/ KR6/exp auto @ f.2*

Samantha was to be a bridesmaid. Her mum asked me to take her picture wearing the dress. I shot on 3m's 1000 rated @ 2000 ISO for the soft grainy effect. This picture is more symbolic of a little girl than a portrait of Samantha.

35mm/3m 1000 @ 2000 ISO pushed 1 stop in process/F KR3/exp auto

Matthew and our dog, Sophie, asleep together on the sofa. It may be a drag to get out of a comfortable chair during a good television programme to take a picture, but it's usually worth it! *28mm/Ekta EL/exp auto*

Woody is Nick's pet hen. We used to let her sit on a towel on top of Nicholas while he went off to sleep – hence this strange picture. A precious memory recorded for Nicholas. *24mm/Ekta EL/exp auto/colour from tungsten light*

Nicholas asked me to take a picture of him holding baby Woody. The light was perfect for a fluffy chicken – early morning backlight. *80-200 zoom @ 120mm/Ekta EN/F A2/exp auto +1/3*

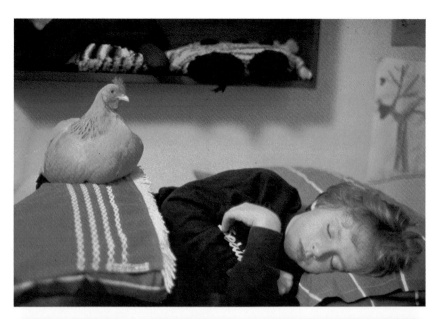

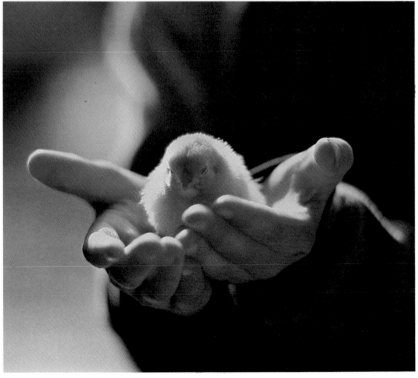

It was an historic moment when Matthew took his first step. He was nervous but overcame that. He was anxious to do it.
(Caption written by Matthew aged 9)

Matt's first meeting with Santa – he wasn't very impressed. I went to the head of the queue and practised on some of the other kids before his turn came along.
50mm/HP5 dev Microphen/exp auto/print gr.4 faces shaded

Bath time is a great childhood memory – Matt's bath times sometimes went a bit over the top!
35mm/HP5/exp auto/print gr.3 background printed in darker

Nicholas watching the trapeze at his first circus outing.
50mm/HP5 dev Microphen/exp auto/print gr.3

Matthew about to blow out his first candle on his second birthday.

105mm/HP5 dev Microphen/exp auto/print gr.4 straight

Matthew in his gorilla mask brings back memories of dressing-up days.

35mm/HP5/exp auto @ f.1.4/print gr.4 face shaded

Michelle and Matthew on the dodgem cars in Brighton – a happy moment.
80-200 zoom @ 150mm/HP5 dev Microphen//exp auto/print gr.3 straight

Our friends Michael and Linda Burgess with newborn Jasmin, photographed in hospital two days after Jasmin's birth. If you don't take this kind of picture, you'll probably regret it later.
35mm/HP5 Microphen dev/exp auto/print gr.3 straight

A special memory for parents – when they finally get to sleep.
35-105 zoom on macro/exp auto/ tripod/HP5 dev ID 11/print gr.4 face shaded

A memory of a freezing day. Nick enjoyed it, wrapped in Michelle's cardigan.
80-200 zoom @ 180mm/HP5 rated 1000 ASA dev Microphen/print gr.5 straight

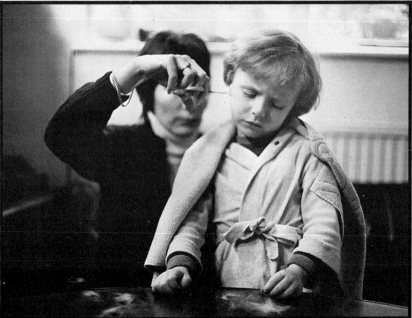

I remember the early haircuts were never joyous occasions.

50mm/HP5 dev ID11/ exp auto @ f1.4/print *gr.3 background printed in*

Sons and daughters

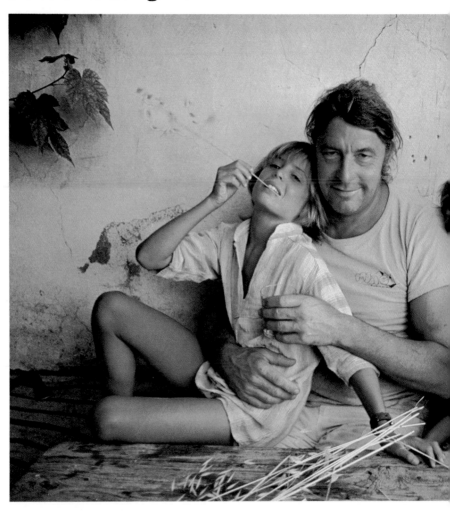

Meb and his family live in a house he built himself in a beautiful valley of Majorca – we were visiting for dinner.

I didn't pose the picture – it's just the way they were. *35mm/EPD/F 81ᴬ/ exp auto*

The wife of our cook in Malindi (Kenya). She is a very relaxed and dignified lady. I took many pictures of her with her daughter. Shot on a long lens wide open to 'lift them off' the background. *300mm/Ekta ER/F 81ᴬ/exp auto*

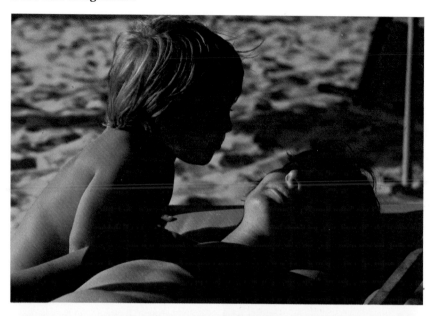

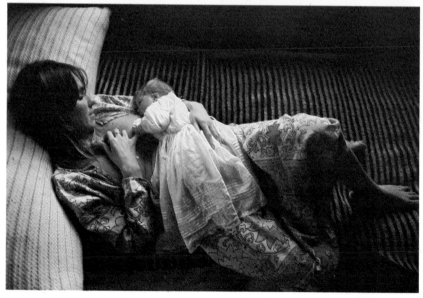

I spotted Matthew sneaking up on Michelle and grabbed the camera. As he kissed her on the cheek I took two shots. I think this first shot of the anticipated kiss is the more charming. *80-200 zoom @ 120mm/Ekta ED/ F81A/exp auto −1/3*

Dorrine was feeding her baby. The light was soft and I exposed for the highlights which makes the picture low key.

The fast film's grain and soft gradation have added to the atmosphere. *28mm/Ekta EL @ 800 ASA/F 81C/exp 125th @ f5.6*

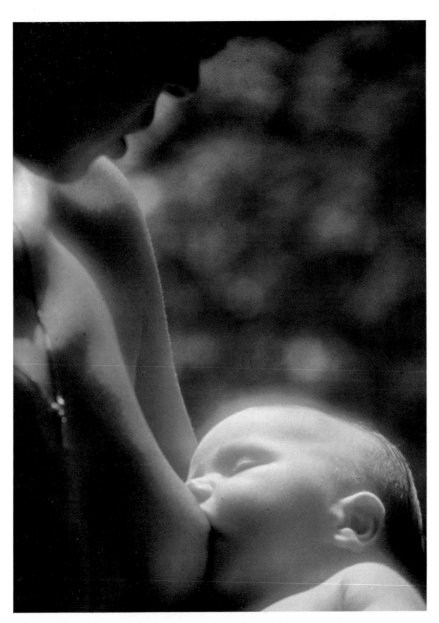

I shot this at a window. I arranged the couple so that the light fell on the baby's face and left the mother in shadow. A softar filter has given a glow to the baby's face. A room light has added warmth to the colour. The lens was wide open to throw the background tree into blobs of colours.
105mm/Ekta EL/F no. 1 softar/exp off baby's face

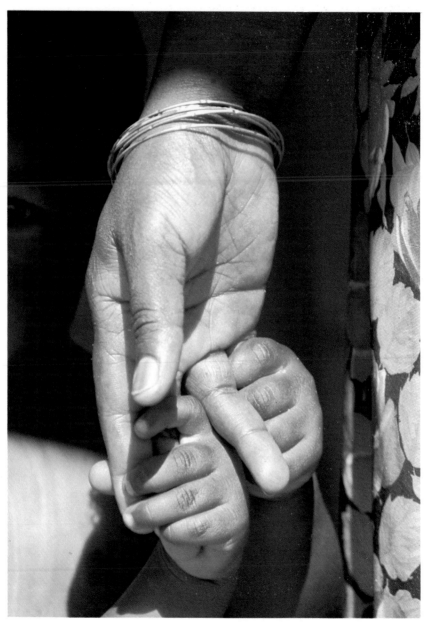

A mother and her twins were standing in the doorway of their house in Gabarone (Botswana). The twins hid behind mum's skirt when I lifted the camera. The two little hands gripping the mother's fingers made a more interesting picture than I had originally planned. *80-200 zoom @ 150mm/Ekta EPR/ exp auto −1/3*

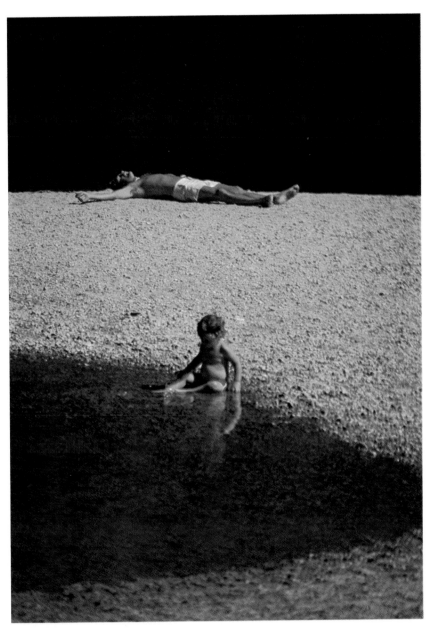

I was amused by the juxtaposition of the father and son. I took the picture during a family holiday in Yosemite National Park (California). By exposing for the highlights I have exaggerated the contrast. I know how the father feels (mother was nearby – awake).

80–200 zoom @ 180mm/Ekta EN/ F81A/exp auto −²/₃

Matthew sat on his Nanna's bed to hear a bedtime story. The yawn comes from tiredness, not boredom – I think! I just popped around the door and took a quick snap, unnoticed.
105mm/HP5 Dev ID11/exp auto+²/₃/ print gr.4 Nanna shaded back, Matt's face printed in

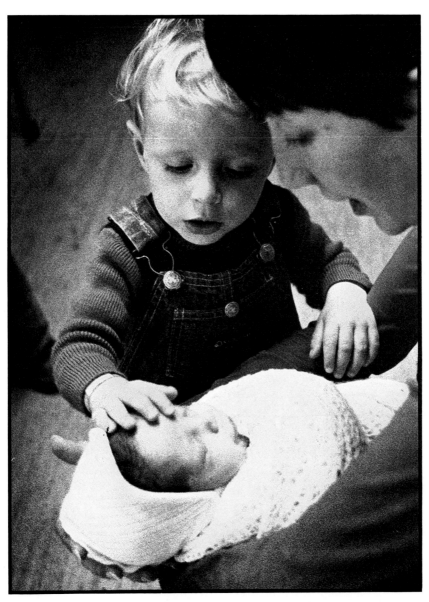

Matthew, Nicholas and Michelle on the first day – in fact the moment in the day, when Nicholas first met Matthew, in the hospital. It is one of our most treasured memories, and I'm grateful that I had my camera with me.
35mm/HP5 dev Microphen/print CR3 baby printed in

Children of the world

I was taking pictures at Sea World in Florida when I spotted this little chap who in turn spotted me – he pulled a face, of course!

300mm/Fuji 100D/F A2/exp auto

This little girl was washing in a river in Sri Lanka. I cropped in tight to emphasize her gold nose studs of which she was very proud. Don't be afraid to get in close

180mm/Ekta ED/F
81ᴬ/exp auto −⅓

Group portraits

I can't pretend that group portraits of children are easy. It is a situation where the photographer must be assertive. The problem is to hold the attention of a group of children on you, eyes at camera, long enough to make a good picture. I always use a tripod so that I'm free from behind the camera to entertain the children. The less inhibited and the more extrovert you can be, the better.

My friend Nancy Howard runs a very unmodelly model agency called 'Little Boats'. Most of her models are the children of friends and are very normal. We arranged this group portrait for a Sunday morning. I hung an old canvas tent fly from my studio balcony, and borrowed some tea chests from a furniture remover. I made a rough sketch of positions for the kids to save time and give us all a starting point (if you mess about at a time like this you have a potential disaster on your hands). The lighting is from window light. I only made a couple of positional changes to the sketch and the picture was finished in 15 minutes. I wanted the children all serious and self-contained. I made some single portraits later. *Hasselblad 50mm/ HP5 dev D76/exp 30th @ f.5.6/print gr.3 straight*

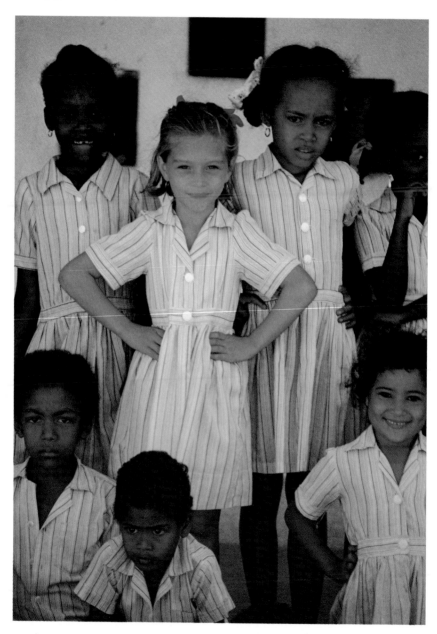

This group portrait has turned out to be almost a single portrait with supporting cast.

The little miss in the middle had a dominating personality. Also, her being the only white skin in the group makes her stand out from her friends. I didn't have to organize this shot. They were already there.
35-105 zoom @ 105mm/Ekta ED/F A2/exp auto

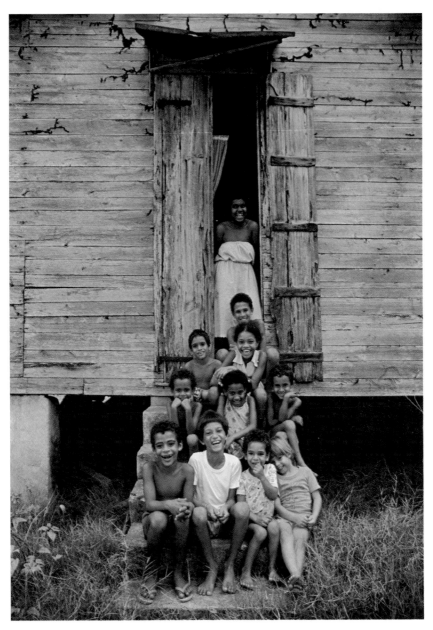

This little group of Seychelloise children were playing together in front of the old house. I loved the colour of the aged weatherboards. I sat the kids on the steps. The picture didn't really come together until big sister popped out into the doorway to complete the composition.
80-200 zoom @ 120mm/Koda 64/F 81A/exp auto

Children of the world

The choir boys of King's College, Cambridge, walk across a little bridge over the Cam every day at the same time. I set up early, 70 metres away, with a 600mm lens and waited.
600mm/Ekta EL/F 81ᴬ/exp auto −²/₃

I asked this beautiful young Samburu girl to pose for a portrait. She did so with the poise and confidence of an experienced fashion model. *80-200 zoom @ 180mm/Ekta ED/F 81^A/exp auto @ f.4*

My niece Chelsea
feeding a Wallaby
at a game park
near Sydney.
80-200 zoom @
150mm/Fuji
100D/F A2/exp auto

A typical Aussie
kid on Bondi beach
in Sydney. I missed
him the first time
and asked him to
walk up the beach
again.
*300mm/Ekta EL/F
A2/exp auto*

Some boys were playing baseball on a vacant allotment in Florida. This lad was waiting to bat, rather disgruntled. A typical American child to me, the tourist. I hung around for about ten minutes till they got bored with me and then took pictures. *80-200 zoom @ 200mm/Ekta ED @ 500 ASA/F A2*

We met on a street in Antalya (Turkey). She was shopping with her mum. I made the portrait from a kneeling position to be at her eye level. Her face is typical of the beautiful people of Antalya – straight out of a painting from a thousand years ago. The aperture was wide open to keep the background out of focus.

80-200 zoom @ 200mm/Ekta ER/F A2/exp auto

I was preparing a
photo story on Eton
School. This young
Etonian is the story
book image of an
English public
school boy.
*105mm/Koda 64/F
A2/exp auto*

On the beach in Mombasa (Kenya). I just snapped a picture that no one could resist. The zoom lens allows you to make a tight crop like this very quickly. *80-200 zoom @ 150mm/Ekta ER/F 81A/exp auto*

This little boy lived in a village near our hotel in Sri Lanka. His mother asked me to photograph him. Although shy, he managed a tiny smile. The window light was perfect. We sent his mum a print.
28mm/Ekta ED/F 81^A/exp read off boy's skin

The young Seychelloise fisherman was waiting on the beach to go fishing with his father. His father and the rest of the family were black – not unusual in the Seychelles where you get an extraordinary (and harmonious) racial mix. The late afternoon light was magic.
300mm/Ekta EPR/F.KR3/exp auto @ f.4

Assignments

KENNY ROGERS·DON WILLIAMS·DOLLY PARTON· DR. HOOK·LINDA RONSTADT
CRYSTAL GAYLE·GLEN CAMPBELL·BILLIE JO SPEARS· JENNIFER WARNES·BOBBIE GENTRY

FRIENDS AGAIN

I was asked to direct a television commercial for the record company, Teledisc, promoting a Country and Western album entitled *Friends*.

The stars of the commercial were to be two children of six or seven years old. I spent a week or so looking for kids who were not only charming but who I thought would work well together. Tom was the next door neighbour of a friend and Jessica was found for me by an agency, but she had never worked before. (I had already auditioned 50 children.)

Jessica and Tom proved to be magic together and the commercial was very successful.

The record sleeves came after the commercial. The designer, George Rowbottom, decided on a stylized, Norman Rockwellish look using the rocking horse that had been a major prop in the commercial. I sprayed the white background a mottled blue with a pressure pack paint to add a sky effect and pre-lit the picture before my stars arrived on set. We shot five or six different poses, working them in ten minute bursts. They already knew each other and me very well from working together on the commercial, so I had only to direct them precisely and maintain their concentration to achieve good results. The delightful charm of these two little rascals was the real point of the whole exercise. My best achievement was to find them in the first place.
Hasselblad 50mm/ Ekta EPR/F AR/exp f.8 with studio flash

NOTE: The *Friends* and *Best Friends* record sleeves were shot at the same session. The *Friends Again* sleeve was shot one year later to coincide with a second commercial.

212

FRIENDS

The Bottoms Up assignment was for Thames Television as part of a self-promotion campaign congratulating some of their largest advertisers on advertising on their channel.

The problem was that they were committed to a picture of a beautiful baby wearing a perfectly fitted nappy (diaper), standing on his head, looking through his legs, smiling at the camera – and they weren't joking!

I organized six babies to be at the studio at 11 a.m. I had pre-lit the picture and made Polaroid tests with my assistant taking the part of the baby. Then he stood by with three extra Nikons ready loaded. The first three babies hadn't read the same brief as me – they offered almost every other pose in the book except the one we were after.

There was a mother at the back of the studio who confided in me that her Jamie had practised last night and could do it perfectly. I replied 'that's very nice dear', or something equally as patronising. I didn't believe her for one moment because this pose was proving to be almost impossible. I worked my way conscientiously through all the babies (you must keep to the order in which they arrive or the mothers could well revolt). We placed sweets on the ground to induce them to bend over and pick them up, etc., etc., but although we had quite a few nice shots, we didn't have the one drawn on the layout. Then came Jamie. I confess to being a trifle jaded by this time and not absolutely 'on the ball'. To my amazement Jamie went straight into the Bottoms Up position – I nearly 'blew it' because I wasn't ready, camera in hand – however, he obligingly remained in position and waited, smiling

triumphantly at me and his failed competitors. I was lucky not to have missed, through loss of concentration, the only few seconds of the whole day when everything was perfect.
80-200 zoom @ 120mm/Ekta ER/F KR3/exp f.8 with studio flash

Congratulations to Procter & Gamble on using Thames Television to really turn the disposable nappy market completely upside down.

'Pampers', Procter & Gamble's first new product launch on Thames breaks on July 1st. A truly adult decision. **THAMES**

BOTTOMS UP.

One of the great pleasures of photography is to watch a good black and white print magically come to life in the developing dish.

I think that the most off-putting thing about home processing and printing is the word 'Darkroom'. In fact, the only part of the procedure that has to be performed in total darkness is the transference of a film from the film cassette into the developing tank. The remainder of the film processing can be carried out with the room light switched on.

Printing and print processing are all done under a darkroom safelight and although the room must be reasonably light tight, if you work at night even that is not critical.

What is critical is *dust*, and this usually excludes the garden shed and places that are inherently dusty. If you haven't an area suitable for a separate darkroom the bathroom or the kitchen is probably ideal. The high-tech darkroom with fitted sinks and benches, elaborate plumbing and electrical fittings is all very nice but unnecessary – you only require electricity, bench space for an enlarger, three developing trays and a packet of printing paper – even running water is not absolutely essential.

The purpose of this darkroom section is to recommend to you the joys and satisfaction of processing and printing your own black and white pictures and to get you off to a good sensible start.

Developing the Film

Before you process your first film, practise loading in old, unexposed film into the developing tank spiral in the daylight until you are absolutely confident of getting the film in without buckling it – try with eyes closed for a while. Set up a routine. Always place the undeveloped films, the spirals, the tank, the scissors and the bottle opener (for opening cassette) in *exactly* the same place *every* time you process a film – *before* you turn the light off. Your hands will then go to the right place for the right thing every time.

1 Hands clean and dry – only hold the film by the edges

2 Spiral thoroughly clean and dry (hair dryer useful).

3 Light off. Undo the top of the cassette with bottle opener, withdraw film on spool.

4 Cut off film leader with scissors.

A guide plan
for a bathroom
to darkroom
conversion.
Paterson's system
is ideal.
1 Exhaust fan –
make it light tight.
2 Towels – clean
and dry.
3 Print timer.
4 Developer with
thermometer.
5 Stop bath.
6 Fix.
7 Chemicals and
measuring jugs.
8 Clip on black out
window screen.
9 Film developing
tank and spirals.
10 Resin coated
paper drying rack.
11 Print forceps.
12 Slip in
temporary bench
over bath. Must be
chemical proofed.
13 Safelight.
14 Enlarger – keep
in dust cover.
15 Masking board.
16 Focussing
magnifier.
17 Multigrade
paper.
18 Bottle opener
(opens film cans).
19 Antistatic
brush.
20 Pencils
(always same
place).
21 Dodgers
(replace after use).
22 Enlarger foot
switch.

5 Carefully feed
film on to spiral.
6 Cut off spool.
7 Load spiral into
the developing
tank and shut the
light tight lid.
8 Light on.
9 Pour in the
developer.
10 Agitate film by
stirring rod or by
turning upside
down, to remove
any air bubbles
that may cling to
film.
11 Agitate every
minute.
12 A few seconds
before time is up,
pour out developer
and pour in stop
bath.
13 After twenty
seconds pour out
stop bath and pour
in rapid fixer.
14 Wash film in
running water for
twenty minutes. Or,
if no running water,
change water every
three minutes for
thirty minutes.
15 Add a few drops
of wetting agent to
water and leave for
a few seconds.
16 Unwind film
from spiral, attach
a clip to both ends
and hang in drying
cabinet.
17 Wipe excess
water off with a
film wiper or
chamois leather.

The first and most important step in developing and printing is to produce a good negative, one that has detail in the highlights and the shadows. To produce this negative should be a fairly simple process – correct exposure in the camera combined with the correct developing time in the correct developer will do the trick every time.

The secret in getting good results in the darkroom is *not* to experiment. I've used FP4 and HP5 films combined with either ID11 or Microphen developers almost exclusively through out my career because I am confident of the results and have enjoyed consistently good negatives from those combinations. I occasionally experiment with other combinations when an unusual effect is required.

The more development you give a film, the more contrast you will get in the negative and the larger the grain structure. The reverse also applies and it is possible when faced with a very contrasty subject to over-expose the film and cut the development time to produce a softer (lower contrast) result. You can also increase the film speed by increasing the development time, but take care because only the highlights are developing up, not the shadows. This is OK for a concert etc. but if you require shadow detail in black and white you must expose for it. Developers fall into groups in much the same way as films do.

A good all round one shot (throw away after one process) developer – Paterson, Agfa Rodinal, Acutol D76 or Johnson's Unitol – is the best starting point. One shot developers are easiest if you're not processing every day. Use one of the rapid universal fixers (used for film or paper).

Negative print

Positive print

Black and white film developers

Developer	Manufacturer	Qualities	Speed rating	Suitable film	Powder or liquid	Remarks
D76	Kodak	Good grain Good definition	Normal	All types	Powder and liquid	Well known, general purpose negative developer
ID11	Ilford	As above	Normal	All types	Powder	As above
Microphen	Ilford	As above	About 60% extra	All types	Powder	Better shadow detail than above
Promicrol	May & Baker	As above	About 60% extra	All types	Powder	As above
Aculux	Paterson	As above	About 30% extra	All types	Liquid	Can be thought of as a liquid D76
Unitol	Johnsons	Fair grain	Normal	All types	Liquid	Compensating type
Perceptol	Ilford	Very fine grain and good definition	Speed reduced to about 50%	All types	Liquid	Sacrifices speed for fine grain and high definition
Acutol	Paterson	High sharpness	About 40% extra	Slow and medium	Liquid	Not meant for fast films
Acuspecial	Paterson	Combines sharpness and fine grain	Normal	Slow and medium	Liquid	Compensating type. Gives details in shadows and highlights but squeezes together middle tones
Definol	Johnsons	Good definition	About 30% extra	Slow and medium	Liquid	Not for fast film
Acuspeed	Paterson	Not fine grain	100% to 30% extra	Fast	Liquid	For maximum speed with fast films
DK50	Kodak	Not fine grain	Normal	Very fast	Powder	A developer very suitable with Royal X Pan

There is a great variety of printing papers marketed by Kodak, Agfa, Ilford and others. All have their own special quality and application but there is no doubt that for the enthusiast printing at home the multigrade resin coated papers such as Ilfospeed Multigrade II and Kodak Polyprint are ideal.

Multigrade is a variable contrast print making system. The contrast of the print is varied by changing filters on the enlarger rather than on traditional bromide papers that have the contrst built in to the paper itself. You require a separate box of papers for each grade of contrast, which is more expensive and more bulky to store than the one box multigrade system. The other advantage of multigrade is that you can print different areas of the print at different contrasts by changing the filters. The resin coated papers wash in two minutes (fibre base paper requires twenty minutes), and dry in a fraction of the time. Multigrade takes the hassle out of printing.

Above left
A Print using multigrade filter no. 1. Print is muddy and flat.

Left
C Print using multigrade filter no.5. Print too contrasty and hard.

Above
B Print using multigrade filter no. 2½. Print brighter and good range of tones.

Right
C Print using multigrade filter no. 3. Slightly brighter than B. My choice as ideal filter for this shot.

221

I inspected the negative and decided on a grade 4 filter. I then brushed the negative carefully with an anti-static brush before inserting it into the negative carrier of the enlarger. Having switched on with the red filter in place I cut a sheet of paper in half and placed it on the masking board across an area which included all the highlights and shadows of the negative.

Experience told me the exposure would be approximately ten seconds with lens stopped down two stops. The rest was a little too light so I made my print at thirteen seconds, which proved correct. As you can see the first print has distracting highlights around Nick's head. In the second print I first exposed for thirteen seconds and then with a dodger covering Nick's face I exposed again

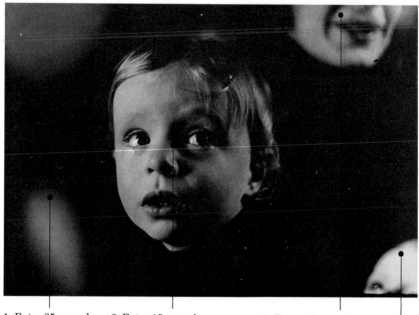

1 Extra 25 seconds printing in.

2 Extra 15 seconds printing in.

3 Extra 25 seconds printing in.

4 Extra 25 seconds printing in.

for another 25 seconds (moving the dodger very slightly all the time so as not to produce a hard edge). I was also unhappy with the highlights on Nick's nose. I printed in the area for an extra 15 seconds by using my hands to shade (see illustration). The highlights are now printed out to black and the resulting picture is far more effective.

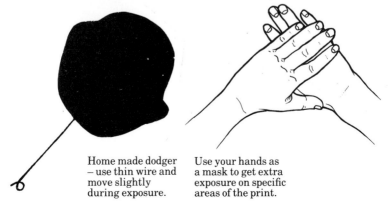

Home made dodger – use thin wire and move slightly during exposure.

Use your hands as a mask to get extra exposure on specific areas of the print.

Print A

Print B

Print of Matthew on Brighton beach

Print A
Printed for detail in the pebbles. A grade 3 filter. The enlarger stopped down two stops. The exposure time was 20 seconds. The detail in the pebbles is OK but Matthew has gone too dark.

Print B
Printed for correct exposure on Matthew. Grade 3 filter. Enlarger stopped down two stops. Exposure time of 8 seconds.

Print C
I exposed for the pebbles (20 seconds) and shaded Matthew for 12 seconds (giving him 8 seconds) with the aid of a dodger that I made by tracing around the image of Matthew projected on the masking board. I cut out the shape but made it smaller in size than the projected image. The result is that Print C has the best of A and B.

Home made dodger.

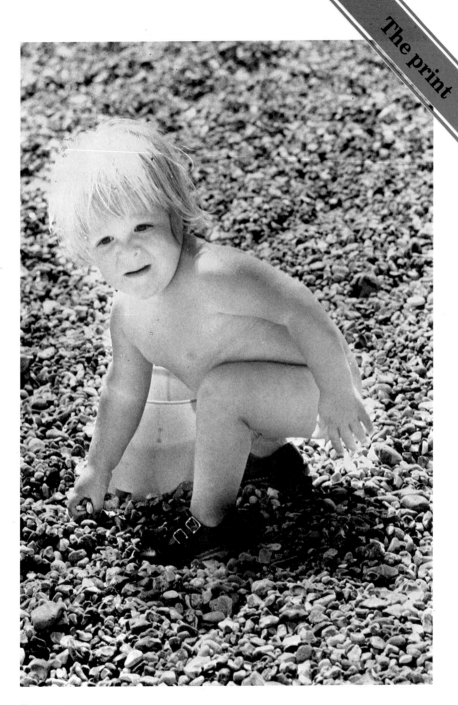

Print C

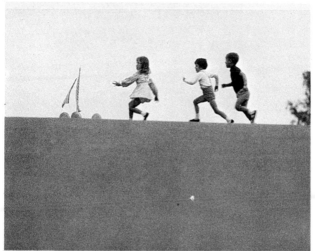

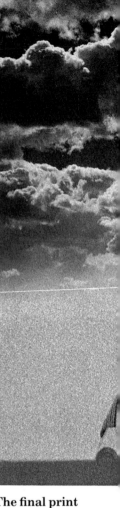

Print A Children chasing yacht

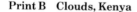

Print B Clouds, Kenya

The final print

Negative A was printed first. I framed up the negative on the masking board marking the position of the children's heads with the piece of masking tape on each side of the masking board. I exposed for one minute with the enlarger lens stopped down two stops, shading off the top edge of the negative with a card so as to avoid a hard edge.

I replaced negative A with negative B (with red safety filter over lens) and lined up sky masking tape position. I placed a penny on the printing paper in the appropriate position. I exposed for twelve seconds (safety filter removed) while shading up the area already exposed by negative A, moving the card ever so slightly all the time to avoid a hard edge where

the sky and the children meet. I
removed the penny and re-exposed it
for eight seconds (card still in place).
The penny has made a moon and the
kids are now chasing the yacht by
moonlight.

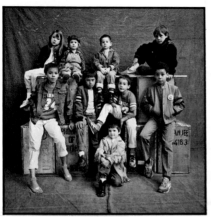

The traditional method of sepia toning bromide prints is using a solution of potassium ferrocyanide. The results are very good but the smell is so appalling (rotten egg gas) that you could have a family revolt on your hands. The Paterson company have come to the rescue with their Acutone Sepia Pack – an inexpensive odour free sepia toner that affords you the opportunity to vary the shade of sepia by varying the proportions of the additive. It's simple and clean to use. I toned this by following the instructions in the book. There are other similar products on the market including tones of various colours.

The print of
Nicholas leaping
over the trees was
made on Rentint
paper (orange)
purely as an
experiment. This
Kentmere range is
worthwhile playing
with.

A colour swatch of
the Rentint range.

KENTINT COLOUR SAMPLES

Matthew is an avid Tottenham Hotspur football fan. He keeps a scrap book of Spurs' memorabilia and he was designing a front cover at the time I was printing in the darkroom – I suggested a photogram. (The boys have made them before.) He cut the shape of the footballer, a cock (Spurs' symbol), and letters out of black paper – after first tracing them off a magazine. He then placed them on a piece of blue Kentint paper to his own design requirements and exposed for five secs. Photograms are great fun for children and a good way to get them involved in darkroom methods. Both our boys will spend hours helping me print (taking twice the time of course).

Colour Prints

There are two entirely different techniques for making colour prints. There are the prints made from colour negative (i.e. the usual print film) and the prints made from transparencies without an internegative.

The method that stands out from the rest is the Ceibachrome print, which is a print made from a transparency relatively simple to make in your own darkroom, of very high quality and low cost.

The great advantage of Ceibachrome is that you first have the positive transparency as a colour guide – very few people can properly 'read' a colour negative. The Ceibachrome print has a plastic base, it's tough and the image is permanent. If you can print black and white in your darkroom you can handle Ceibachrome too.

Kentmere are a small independent manufacturer of photographic paper and film. They produce the Kentint range of resin coated papers which are coloured enlarging papers (see colour swatch) that can be printed and processed in exactly the same way as conventional papers. They are great fun for posters and exhibitions. Colour using black and white negatives.

Glossary

Aperture
The hole in the lens that allows light to pass through and expose on the film when the shutter is open. The hole is variable in size which is measured in F stops.

Aperture priority
The auto mode when the photographer sets the aperture and the camera adjusts the shutter automatically to achieve correct exposure. When the depth of field (controlled by the aperture) is of prime importance rather than the shutter speed.

ASA
The American Standards Association rating of the sensitivity of photographic emulsions to light: the higher the rating, the more sensitive (faster) the film.

Auto
Camera setting for the camera to make automatic exposures.

Bounced light
Light reflected off a surface.

Centre weighted
The metering system in a camera where the exposure is taken off the centre of the film plane.

Clip test
Test processing of a portion of a roll of film to check exposure.

Colour saturation
Saturated colour is colour that is a full intensity.

Crop
To cut in to a part of the subject leaving it incomplete in form, e.g. crop the top off the head of a portrait for a more dynamic effect.

Cut
To rate a film at a lower (ASA or ISO rating) speed than the manufacturer's recommendation.

Cut processing
Reducing the development to compensate for overexposure.

Colorama
A brand name for a range of 9' or 12' wide rolls of coloured background paper.

Density
The degree of lightness or darkness of a transparency or negative.

Depth of field/depth of focus
The distance that remains sharp in a photograph from foreground to background determined by the F stop of the aperture.

Diaphragm
The mechanism that controls the aperture.

Fast film
Film with a high ISO or ASA rating, e.g. 3M's 1000.

Fast lens
Lens with a large maximum aperture, i.e. 50mm F1.2 lens.

F stops
The method of calibrating the aperture size.

Focal point
Point in the picture that attracts or draws the attention of the eye.

Grad
Graduated filter.

Grain
Silver halide crystals of a film emulsion visible in a transparency or print. The faster the film the coarser the grain.

Graphic; graphic effect
Making a strong design or pattern from the shapes, lines and colours in a picture.

Hard-edged colour
Extremely strong definition between colours in a photograph, emphasized by simple strong compositions.

Highlight
The brightest part of the photograph. Opposite exposure value of a shadow.

ND filter
Neutral density filter, used to cut down the volume of light. It has no colour of its own.

ND grad
A graduated neutral density filter.

Open up
To change the aperture setting to a larger setting, e.g. F8 opened up to F5.6 (doubles the volume of light entering camera).

Overriding auto
When you use exposure compensation dial to alter the automatic exposure.

Push
To rate a film at a higher
ISO or ASA rating than
the manufacturer's
recommend.

Push processing
Increasing the
development to
compensate for
underexposure, i.e. ED200
pushed to 400 ISO =
under-exposure of 1 stop
requiring development
increase of 3 minutes in
first development.

Short lens
Wide angle lens.

Shutter
The mechanism that
controls the length of time
that the light is allowed to
expose on the film.

Slow film
Film with a slow ISO or
ASA rating, e.g. KODA 25.

Softar
The brand name of the
Hasselblad soft focus lens
of filter.

SLR
Single lens reflex.

TTL
Through the lens
metering.

Uprating
Lifting the ISO (ASA)
rating above the
manufacturer's
recommendation (push).

Warm colour
Colour strong in the red
.end of the spectrum.

Washed out
Colour that has
insufficient saturation –
usually caused by over-
exposure.

Acknowledgements

Thanks to

Paul Barron and staff of Tecno for sound advice. Terry O'Neill and her staff. The parents and children of the Vale School for their generous assistance. Hilary Davies for her support and editorial expertise. Maureen Korda for expertly typing the manuscript from my appalling handwriting. Kate Wright for extra typing service beyond the call of duty. Robin Bell for some excellent printing. Nancy and Tony Howard for organizing my group portrait. Julian Calder for being a tower of strength on the first two books. To all the children and parents who made this book possible. To all my clients whose assignments added material to the book including Kodak (Paul Wigmore), Barclays Bank (Peter Gittoes), Sunday Times, Sunday Express magazine. Teledisc record company etc etc. Shobna for cleaning around my mess for 4 months. To Michelle, Nicholas and Matthew for everything.

Index